FOR AVA & ELIZABETH

RASKOLS

RASKOLS

THE GANGS OF PAPUA NEW GUINEA

BY STEPHEN DUPONT

INTRODUCTION BY BEN BOHANE

powerHouse Books
BROOKLYN NY

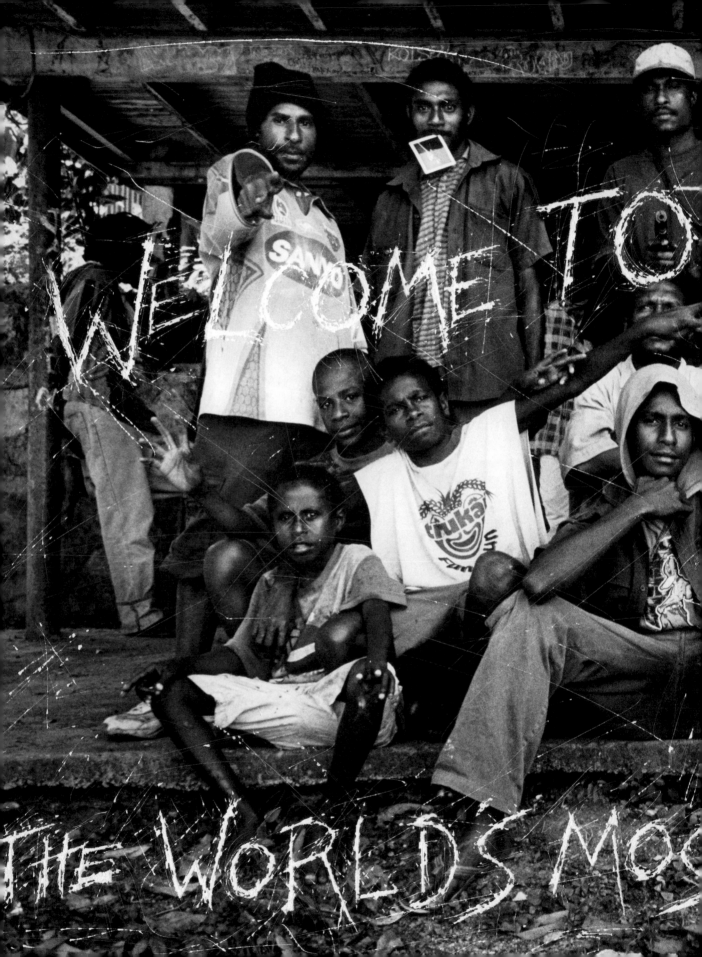

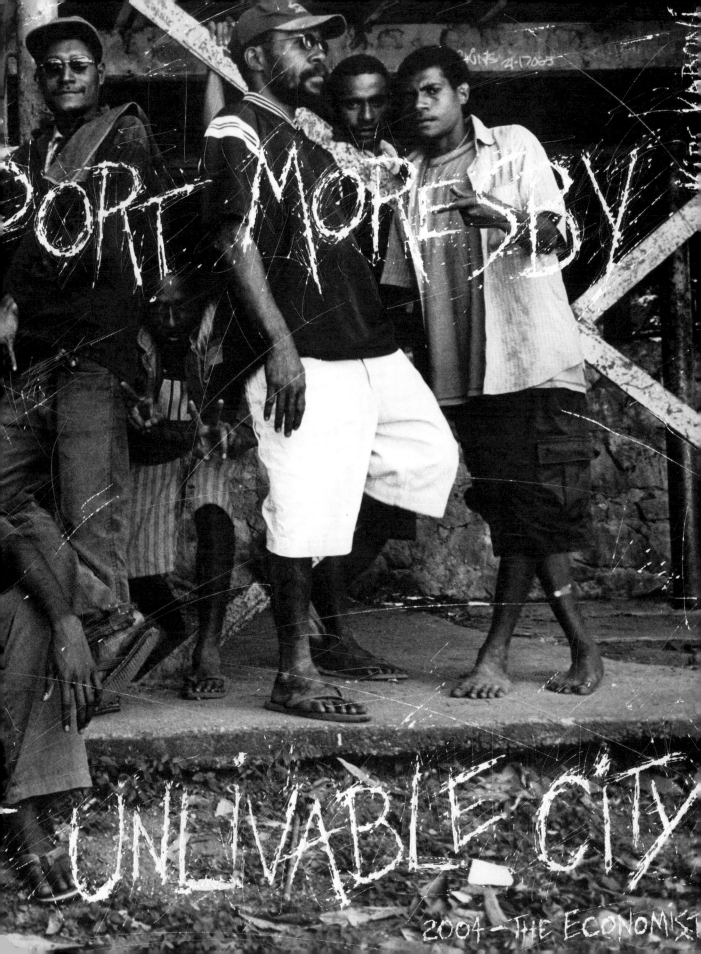

PORT MORESBY

UNLIVABLE CITY

2004 — THE ECONOMIST

THE GANGS OF MORESBY

They'd left him for dead.

KGK gang members had watched Allan Omara leave the Islander Travelodge hotel after a few too many drinks. Outside there was a verbal exchange, then someone lunged at him with a knife and he was left to bleed in the nearby bushes, a 40 cm gash in his side.

The year was 1979, when Omara was something of a rookie raskol earning his spurs on the streets of the Papua New Guinean capital, Port Moresby. Post-independence euphoria was starting to ebb; the gangs had not only become more professional in their criminal operations, but had begun fighting each other over turf.

It all started to get serious in the late 1970s, after independence, when gangs got organised and the cops got armed, remembers Andy Amex, a veteran of Moresby's gang scene, as we sit inside one of the Kips Kaboni gang safe houses in the Kaugere settlement. He adjusts his waist-length dreadlocks, now grey, and looks thoughtful for a moment.

Luckily we saved Allan that day, but he lost a rib and his spleen. Kaboni was the top gang back then and still is, he smiles proudly and glances over at Omara, who is fiddling with the spring mechanism on a homemade pistol. Buying weapons has always been expensive, so local gangs improvise, often using bored-out iron pipes with hand-carved wooden butts (or pistol grips), held together with thick rubber bands. Crude "homemades" using .50 calibre ammo left over from World War Two are not precision weapons, but will put a deadly hole in someone at short range.

Today, Allan Omara is no longer a rookie among Moresby's hard men. He is the retired General, leader of the "mother gang" of all major gangs in Papua, which include the 585s, 105s, KGKs, Mafias, Boimai, and Kips Kaboni. *Kaboni* means "devil" in the local Motu language, and the gang Omara led until recently is still responsible for a good chunk of the crime committed in Moresby, ranging from armed robberies and political intimidation to insurance scams and the trade in ganja and guns.

To dismiss the raskol gangs of PNG as merely thugs, however, is to miss the true picture (although *raskol* is pidgin English for criminal)—they are also the barometer of grassroots dissatisfaction in a tribal country still grappling with modernity. Like the *favelas* of Rio and other ghettos, they are both revered and reviled by communities who rely on them to feed and protect them at times of ethnic tension and government neglect.

We are not raskols for fun. We are raskols because it is the only means of survival for us and our communities, Omara says.

The problem is PNG has a fast growing population, very high unemployment, little education, and we have a police force that is corrupt, politicians who are corrupt, and a defence force which is corrupt. Up to today, our activities are the only way our communities can survive.

I have been coming to PNG every year since 1994, covering the secessionist war in Bougainville, the raskol gangs and tribal fights, its sorcery and cult movements, and the plight of 10,000 West Papuan refugees along its border with Indonesia. New Guinea island—the largest tropical island in the world—has always been a place like no other, the Amazon of the Pacific. The eastern half, PNG, has seen 1000 tribes and languages merging into a modern nation state since independence from Australia in 1975, while the western half (West Papua) still struggles for independence from Indonesia. I have always marveled at its beauty and wildness, the resilience of its people and its penchant for the unexpected. Indeed there is no truer tourism slogan in the world than PNG's official *Expect the Unexpected.*

In 2004, I accompanied Stephen Dupont, a longtime compadre, to PNG. Dupont has built a distinguished reputation covering many of the toughest places on earth, from Rwanda to Palestine and Afghanistan.

A magazine assignment provided the opportunity to work together on a story about the raskol gangs of Moresby. Although feared, I have gotten to know many of them over the years, and knew that they respect those outsiders not afraid to come into their communities with a grassroots approach, rather than the behind-the-wire fortress mentality of many residents and visitors. Steve immediately engaged with the Kaugere community, and went to work framing portraits of gang members that hover darkly between menace and a tangible vulnerability. He has a knack for capturing the invisible substance of portraiture that renders his subjects both hard and humane; he gives depth to personality, gives face to troubling ideas.

Inside a gang safe house covered in debris and biblical quotes, we negotiated consent. With minimal setup, Steve set to work building a collective portrait of young, urban New Guinea. We can gaze now into the eyes of a Pacific people whose challenges are evident, but not alienating. They say: *Engage with us, we are not hostile despite our tough-guy exterior. We want to be friends, and so we remain.* Steve has been back several times since, gifting photo prints and rugby league jerseys for the Kaugere Bulldogs, pride of the community. Weekend football matches are a community highlight.

Although it has a somewhat violent reputation, PNG remains a place of great natural beauty from

its mist-soaked highlands to shimmering tropical islands.

In 2004, however, *The Economist* magazine surveyed 139 of the world's capital cities and ranked them according to how "liveable" they were. No cigar for guessing which city was 139th—last—on the list. There is no point trying to paint a rosy picture of Port Moresby, or *Mosbi* as locals say, but is it really, officially, the most "unlivable" capital city on earth?

Personally, I don't think so, and neither do many of my friends who have long made it home. OK, many people live in barbed wire compounds, and the city has no real tourist attractions or quaint colonial architecture to coo over. An air of tension hangs over the city at night, but it is not the fear found in cities torn by war; it is a quieter menace that just makes going out more complicated. It is a place where friends will come by and casually drop their car keys on the table—along with a 9 mm Baretta. Everyone who has lived here has a horror story to tell.

Yet despite all this, Moresby does have a certain charm. There is an afternoon glow as you cruise the rolling hills around *Kila Kila* at sunset, with vistas of the Coral Sea, and I know my friendships here are for life. I watch the morning rituals unfold here like any village: the women at dawn with big hoops of fishing nets, the laugh of red-gummed *buai* (bettlenut) sellers, men strolling pensively amidst rooster crows.

In the heart of the settlements, you don't really feel like you're in the city, just a big pot-holed village. Once out of the towns, Papua New Guinea opens up into great panoramas of mountain, jungle, and beach. It is a treasure trove of stories and anthropological weirdness. For 100 years it had been Australia's wildest frontier, providing legends that have seeped into both national mythologies: the early traders, pearlers, and beachcombers who settled here, the proverbial mercenaries, missionaries, and misfits; Kokoda, Buna, and Milne Bay, battles that halted the Japanese advance in WW2; extraordinary characters like Jack Hides and the Leahy brothers who made first contact in the "Shangri-La" of the highlands in the 1930s.

In 2004, Steve and I came to PNG just as plans were underway for a contingent of hundreds of Australian police to be deployed to assist their PNG counterparts in dealing with increasing law and order problems. It was a controversial deployment on all sides and later put on ice after court challenges. In the meantime, Allan and the Kaboni boys had been chewing over the implications.

There has been some negative talk about the Australian intervention, but for myself I think it is a good idea says Allan. *There's too much corruption here and the police don't do their job properly. I don't think there will be any armed opposition to the Australian force.*

Isn't Omara concerned that he and the Kaboni boys, like other raskol gangs, will be targeted?

Yes, we are concerned they will come after us, but like I said, it is a matter of survival for us. We have no choice but to continue our activities until we get arrested or shot.

Rappers like 50 Cent might claim it is best to get rich or die tryin', but for this South Pacific posse, it is far more basic—it is about feeding their families and protecting their communities. Of course this excuse can hide a multitude of sins, and there is no justifying gang rape and violent robbery, but such deeds are often the by-product of a society that has lost faith in national institutions and their leaders. Allan says his boys have always drawn the line at rape—*everything else is OK, for a price* he laughs.

Prison is nothing to fear—indeed it is a rite of passage for the modern raskol in a way that mirrors the harsh tribal initiations of old. One gang member says:

Prison is just a university for raskols—we go in as petty crims, get three meals a day and come out more professional, more hard than when we went in.

On a return trip, Steve and I came to the Kaugere settlement in the middle of a tense standoff between local Papuans and Tari highlanders who had settled or squatted here. The night before we arrived, a local woman had been killed, speared through the head with an iron bar by a drunk Tari highlander. PNG society has long operated on a payback system of retribution; when tribal wars start, they can descend into endless cycles of payback that can be hard to break. It is a place rooted in Old Testament justice, not the New.

There is suddenly a flurry of activity in Kaugere as the mostly Papuan community set up armed roadblocks while the women and children huddle at night in the basketball court in the middle of the settlement. The man responsible for the killing was found and beaten to a pulp by Papuan men. In the morning heat we are taken to the still smoldering ruins of trade stores, owned by highlanders who had fled, all torched the night before.

Get them out! screamed several placards in protest, days later, as locals ask police to come and permanently remove the squatting highlanders. Police and their elected MP Bill Skate (a former Prime Minister who grew up in Kaugere and once boasted on TV that he was "the godfather" of Port Moresby's gangs) fail to turn up and the situation is tense—we don't know if the highlanders will come back on a rampage. The previous time I had been in Moresby, Tari highlanders had gone through the Morata settlement and butchered 10 Goilalas (a Papuan tribe) with machetes, including a two year old boy.

The man responsible for defending Kaugere at this time, since there is no police protection, is also the Kaboni gang leader, Allan Omara, underlining the symbiotic relationship gangs usually have within their community. His boys are posted on 24-hour watch, and that night I observe shadows

moving near a checkpoint. It turns out to be three PNG Defence Force men in full combat rig, keeping an eye on things.

They are our guys from the community, who are in the DF [defence force] says Omara. *If there's trouble then we got some backup.* He hints there are automatic weapons, not just machetes and homemade pistols at hand.

Over the next week the situation calms and a traditional reconciliation process gets underway, with pigs killed and compensation agreed to for the dead woman's family. We spend a week hanging in one of the safe houses, which doubles as a Christian community centre. The walls are covered in Psalms exhorting *Come seek the protection of the Almighty for no weapon shall be raised against Me.*

Many of the gang members will spend their lives drifting between Christianity and raskolism. One member says in rather pragmatic terms:

I tried to walk the path of Jesus but it was no good; there was no cargo [material goods]*, no work, no girls. Now I travel the road of Satan and it is much better—I can get what I want.*

The use of sorcery is part of daily life for most Melanesians, so it is not surprising to hear lurid stories of devil worship around Moresby. The burning of a primary school is blamed on Satanists; a spate of witch killings in the highlands is pinned on fundamentalist Christians. No wonder people are confused.

Omara insists, however, that the Kaboni gang is not here for Satan's work. *We don't worship Satan and in fact many of the boys are Christians* he says. When pressed, he speaks of hearing about some raskols who invoke Satan before they go out on raids, who tear pages out of the bible to use as rolling paper for their *spak brus* (literally "electric tobacco"—ganja), which they smoke in the hope it will turn them invisible when they do their dark errands.

The Kaugere community was home to the first raskol gangs in Moresby, back in the late '50s according to Andy Amex.

Amex is a quiet, Rasta-handsome man who has traversed the spectrum from raskol gang leader to community leader, and even stood in local elections some years back. He is an expert boxer who doesn't pull his verbal punches either:

The politicians blame us for all the troubles but they are the biggest raskols and biggest thieves of all. They have sweet mouths but they never look after us grassroots he laments.

Amex has the oral history of Moresby's gang scene going back nearly 50 years.

The first outlaws were known as "DDs," the "Devil's Disciples," who were Kerema men [a Papuan tribe from Gulf province, from which Amex and Omara both come] *living here in Kaugere in the late 1950s. They were mostly into theft and petty crime. As Moresby expanded, new gangs started to form and create their own territory.*

After DDs came The Devils as the next generation. There was also some whitefellas involved in the 1960s and 70s; Aussie kids born and bred in PNG who joined the gangs and came under our roof. At first they did petty crime, like selling ganja, but later on they did more serious stuff like armed holdups. Back then it was harder for the gangs to operate because during the taim bilong masta [Australian colonial period] *the law and order was much tighter. It was much more peaceful then, lots of hippies you know, it was the age of flower power and there were plenty of jobs, not like now.*

Amex says after *The Devils* came *Kaboni,* which is when he got involved. *That's when the ganja first came in. We had big plantations of it up at Sogeri, near Kokoda, so we'd bring it into town and sell it at a club called The Pink Pussy. It was Aussies who introduced it here but then we took over the trade.*

These days much of the ganja sold in northern Australia is the infamous *PNG Gold.* Amex says the trade is measured in tons, not kilos. For decades, the islands of Torres Strait in far north Queensland have been the gateway for cross border trade in guns, ganja, and more recently, people smuggling.

Amex relates how there was a lot of inter-gang fighting in the 1980s, but from the 1990s until today, the gangs recognize each other's turf and mostly co-operate. Sometimes they will even provide weapons and men to rival gangs for certain operations—for a cut of the proceeds of course.

There have been some spectacular robberies over the years, some involving helicopters, and police complain that they are sometimes outgunned and outsmarted—some gang ops are clearly done by ex-soldiers.

The 1990s saw international connections become more established. Organised crime outfits from Australia, China, Indonesia, and Russia got involved in the guns-for-ganja trade. Alluvial gold was swapped for automatic weapons, while underground casinos beneath Chinese restaurants ran money laundering operations. During the 1990s, gangs got seriously armed and politicians increasingly used the raskols as muscle both for their own protection as well as attacking opponents.

Grassroots frustration and ethnic tension continue to grow in PNG, and its neighbours face a hard task if they do intervene one day. Many wonder if regional intervention, similar to the RAMSI

mission in the neighbouring Solomon Islands, will one day unfold in PNG.

All the guys are happy for the Australian intervention. Some of us even say we should go back to being part of Australia and forget independence Amex says. For now, however, there are few options but to continue their raskol reign.

There will be no change when the Aussie cops are here, because when you are hungry you have to get food by any means available. It's survival.

The Kaugere settlement typifies the urban challenges ahead for many Pacific nations like PNG. Half the population of the Pacific is under 21 years of age, and rapid urbanization is changing what it means to be a Pacific Islander in the 21st century.

Kips Kaboni and other raskol gangs present a tough face, but that comes from living tough lives. Like the smiles that can crack through the cold stare of a gang member's face, the sun still shines on Kaugere and the rest of PNG, as they build community and hope for better opportunities ahead.

Massive oil and gas developments promise new wealth (as well as a resource curse) that will either transform Moresby into a much more livable city, or exacerbate the division between haves and have-nots. Either way Allan, Kips Kaboni, and the Kaugere settlement will do what they can to survive and prosper, regardless of the law.

Stephen Dupont's edgy portraits of Papuans with tribal instincts but urban lives do not seek to put distance or differences between us. They are not to evoke fear or revulsion, but acceptance and engagement, to highlight a global struggle of ordinary people on the margins of society who just want a better deal. Here, most importantly, they want to keep living the *Pacific Way.*

Ben Bohane
Port Vila
June 2011

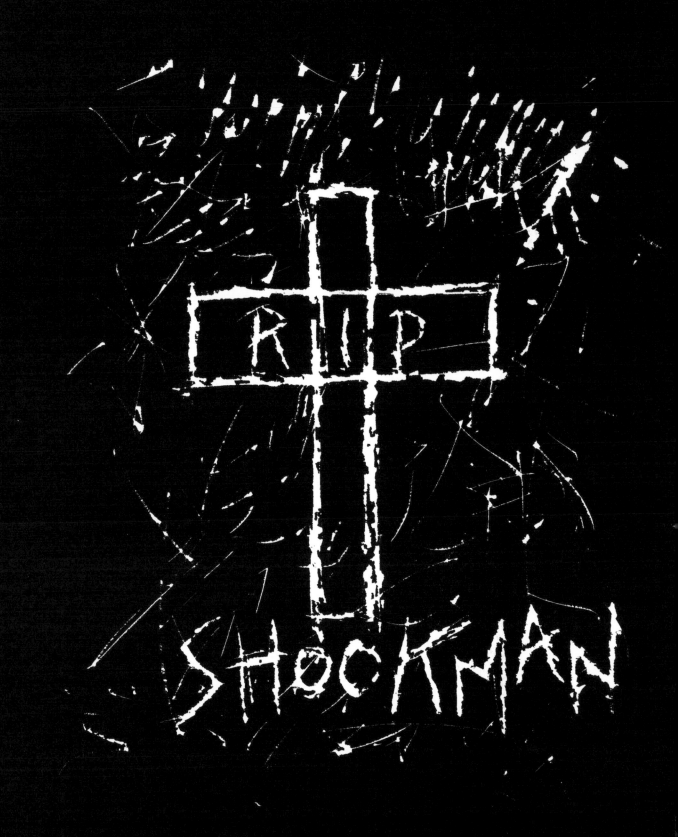

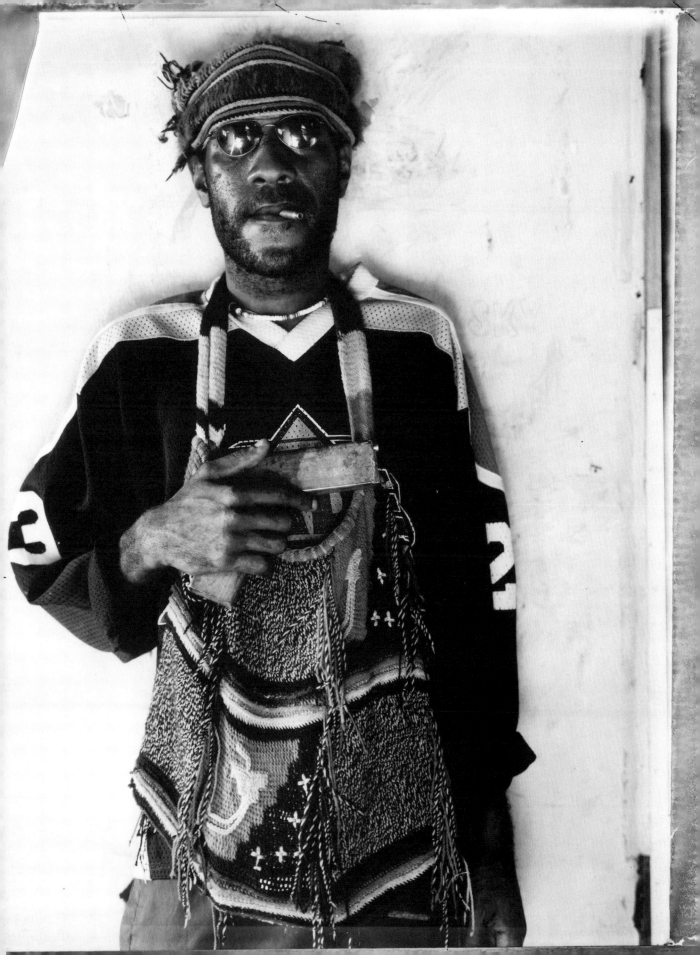

ACTING POLICE COMMISSIONER — MR BAKI

"MANY PEOPLE COMMITTED CRIMINAL ACTS BECAUSE THEY HAVE NOTHING TO DO"..... SO THEY ARE SITTING AT HOME EATING THEIR CORNFLAKES AND SAY TO THEM-SELVES......"I'M BORED; I HAVE NOTHING TO DO TODAY; I THINK I WILL GO AND MURDER JOE DOWN THE ROAD BEFORE LUNCH. THEN HAVE A BOWL OF RICE AND TIN FISH AND GO RAPE THE FIRST THING I SEE WITH BREASTS (ANIMALS EXCLUDED)."

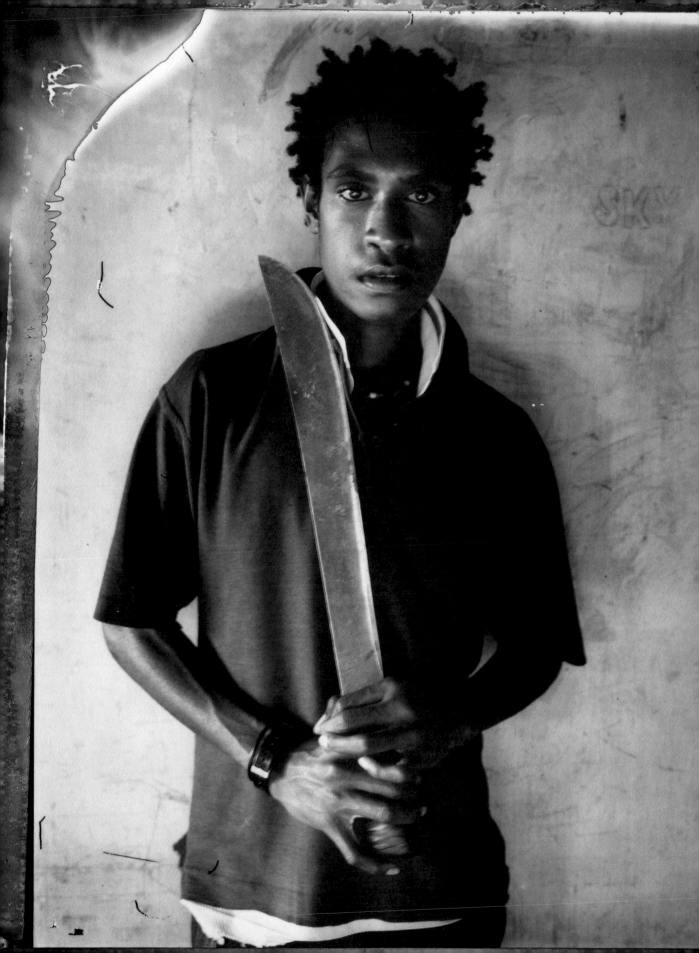

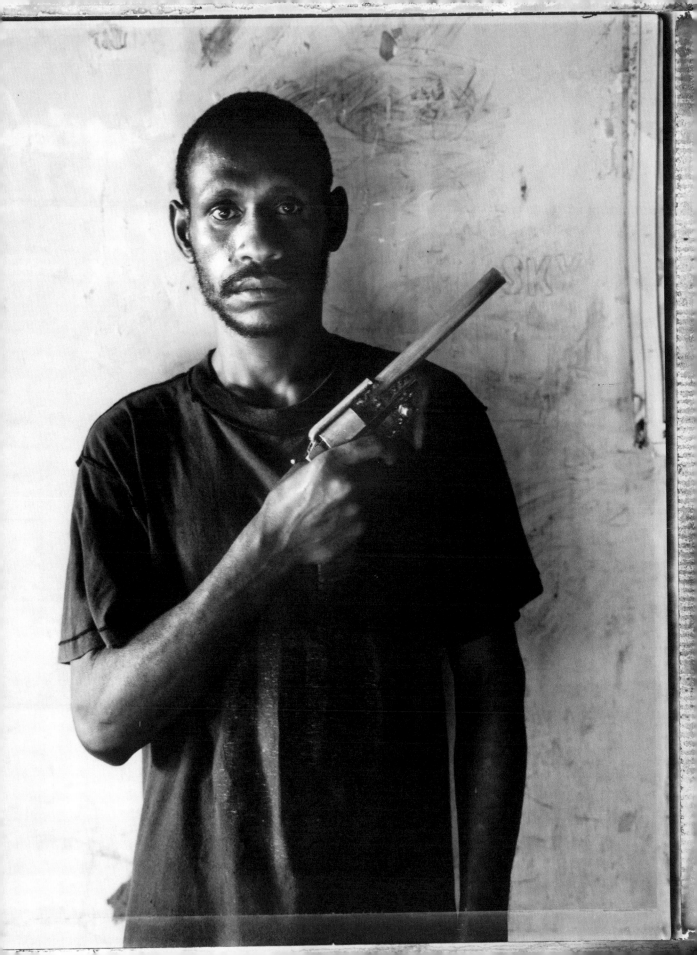

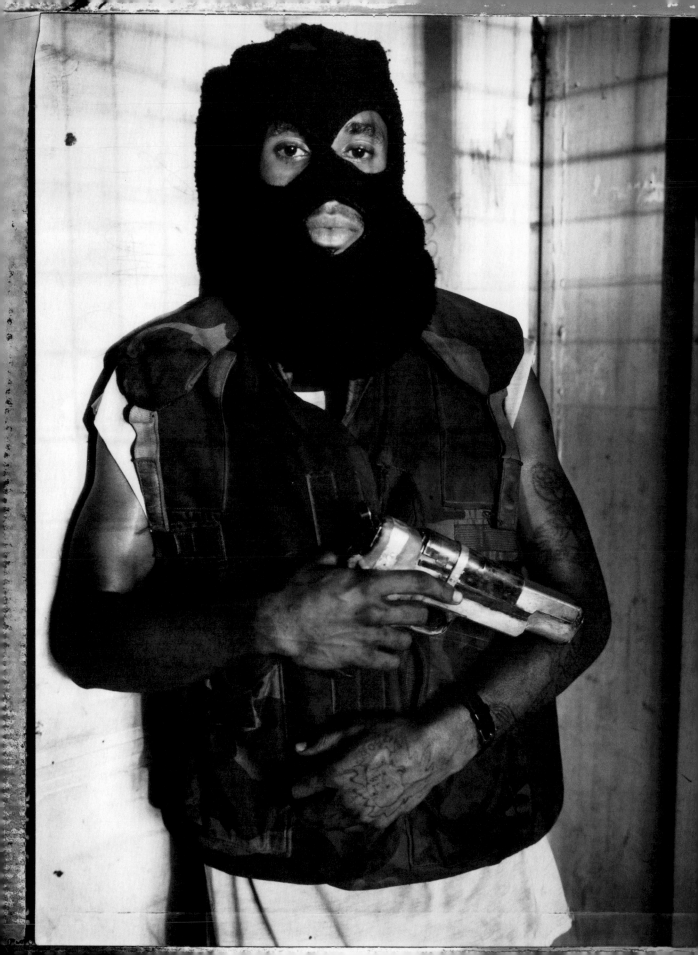

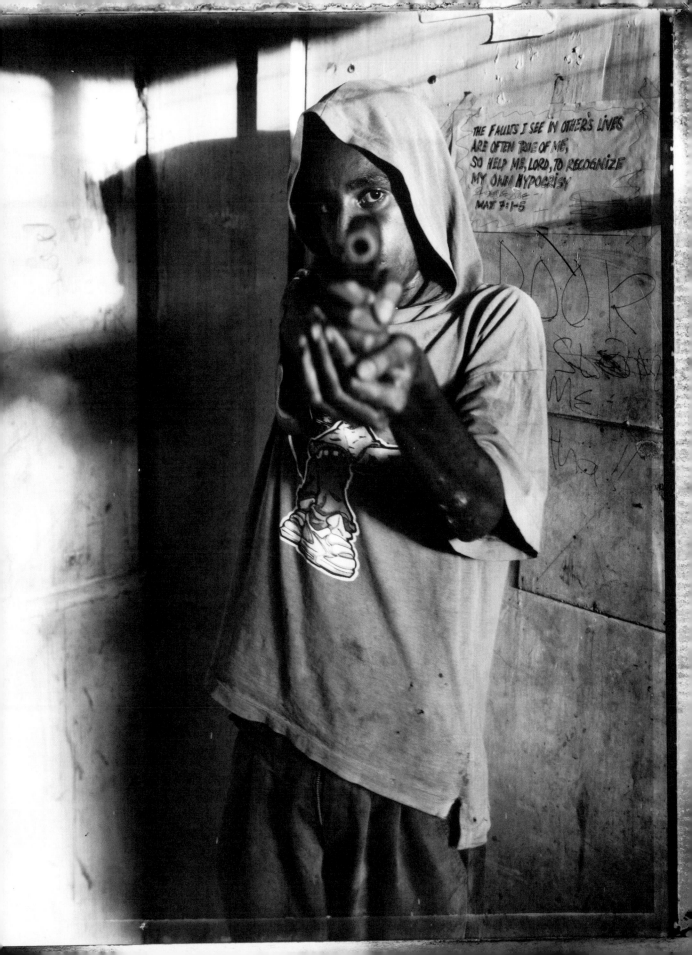

THE FAULTS I SEE IN OTHER'S LIVES
ARE OFTEN TRUE OF ME,
SO HELP ME, LORD, TO RECOGNIZE
MY OWN HYPOCRISY
MAT 7:1-5

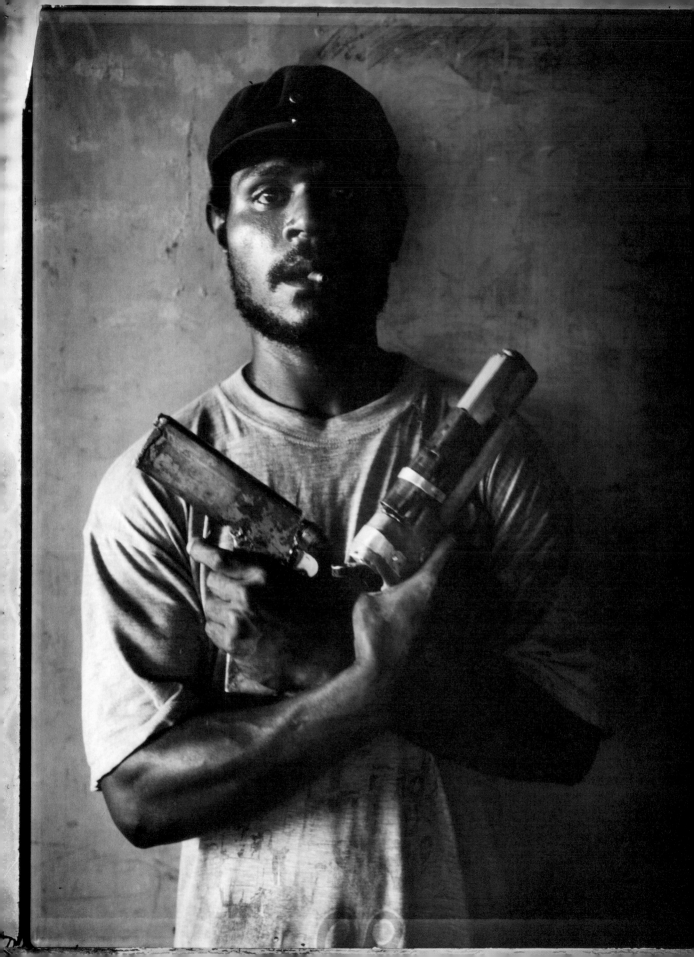

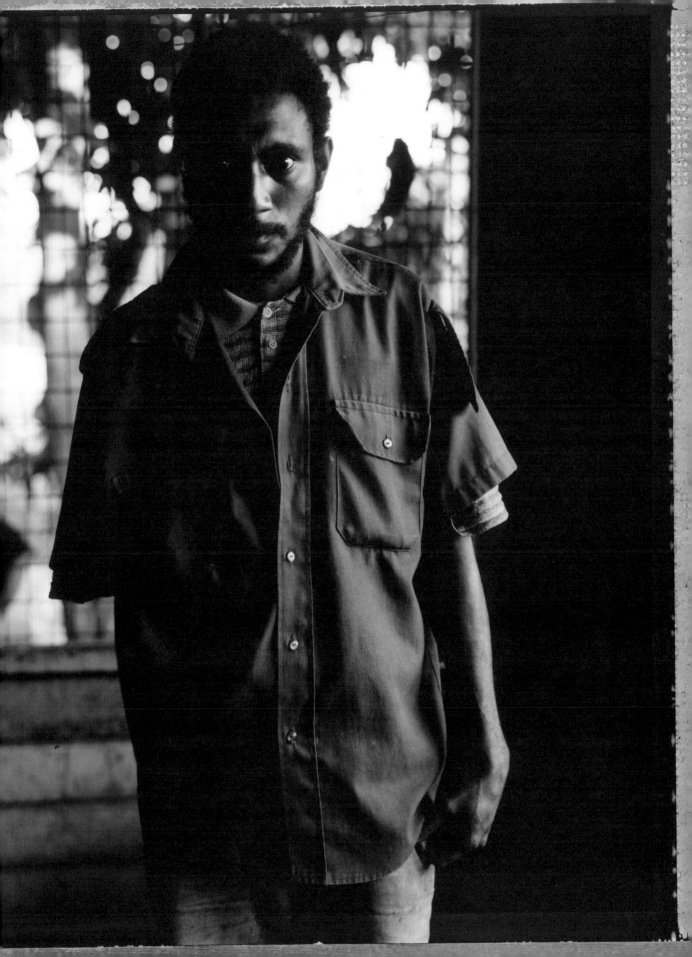

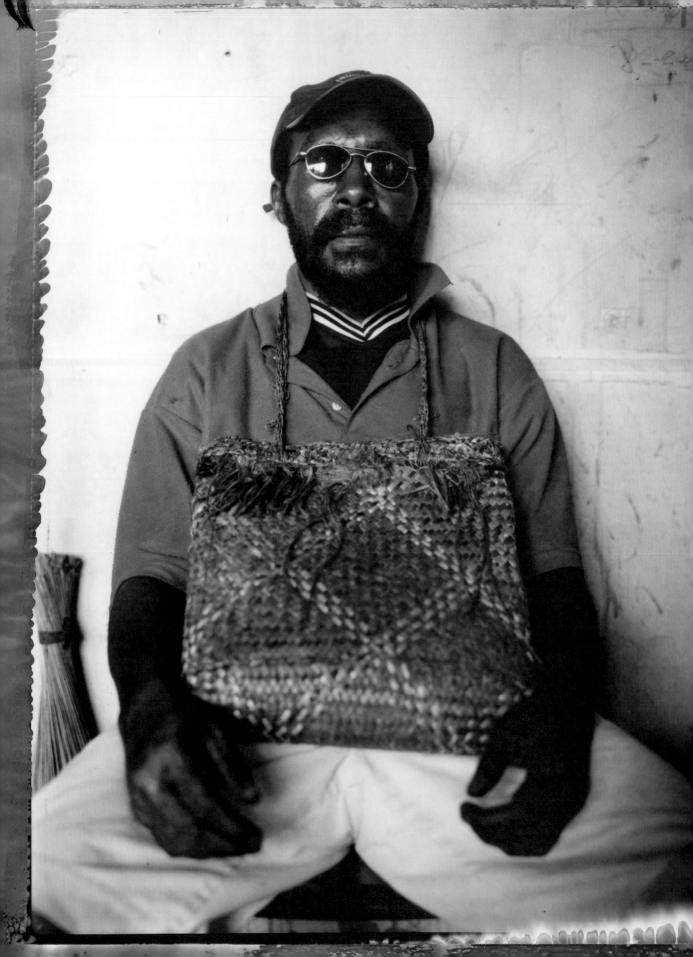

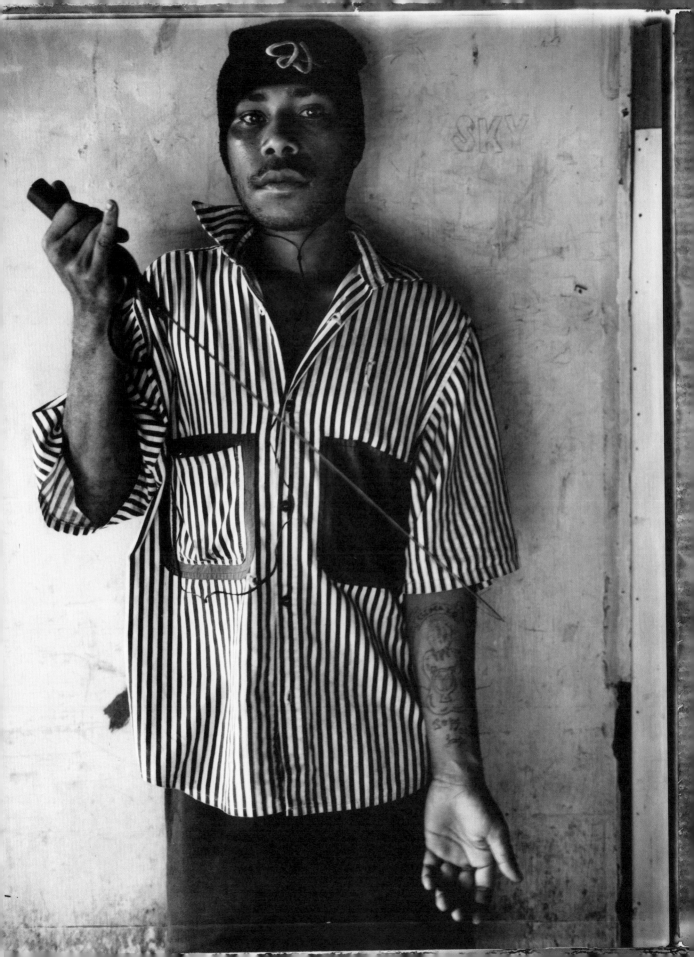

"HE LUNGED AT ME WITH A KNIFE, OPENING ME UP, HE LEFT ME FOR DEAD, BLEEDING IN THE BUSHES."

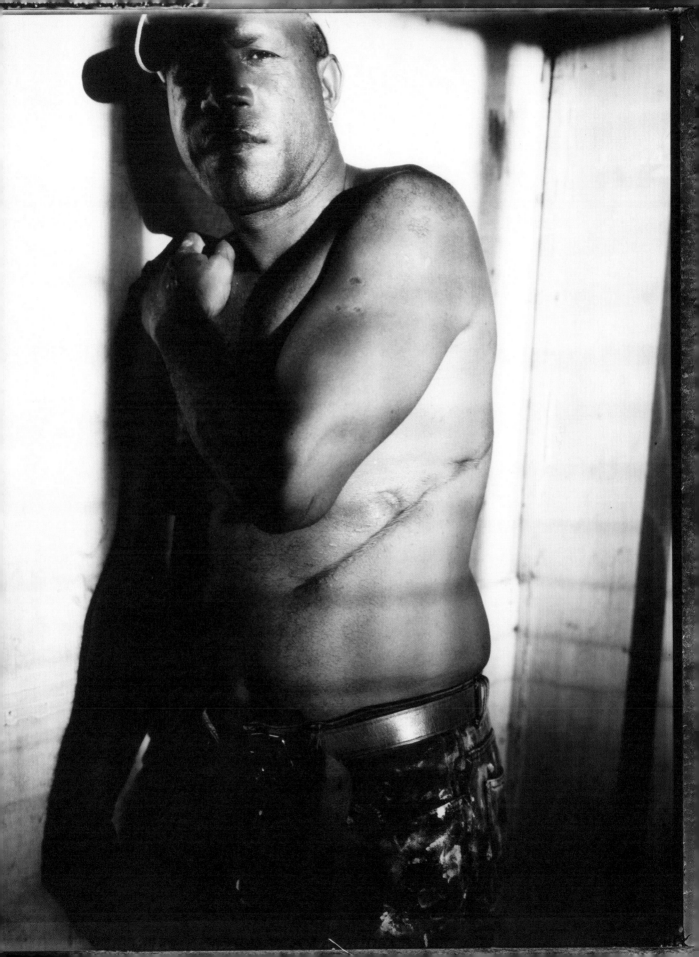

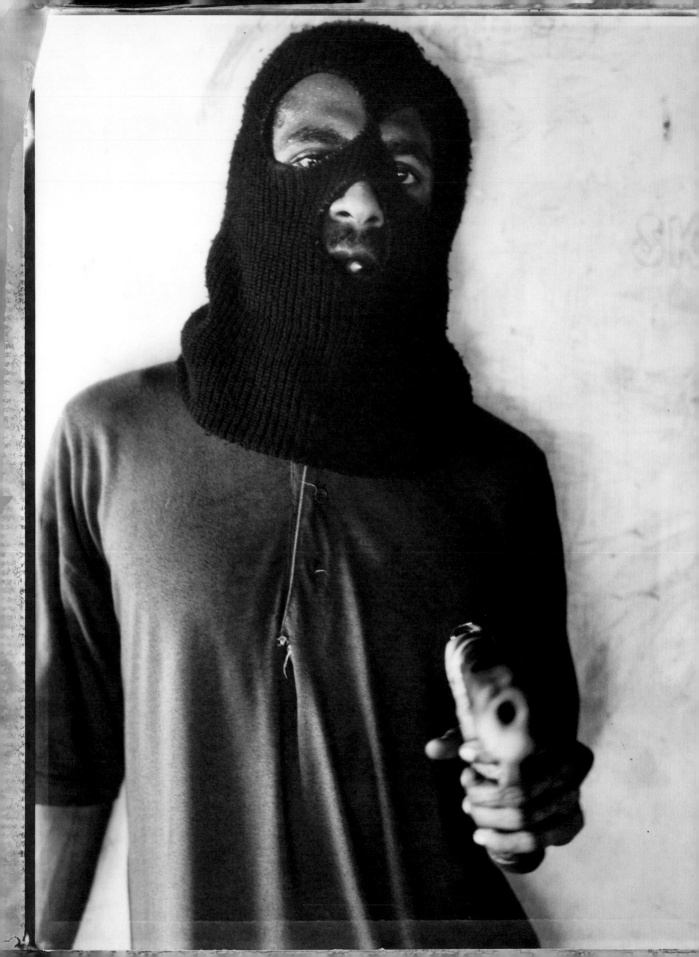

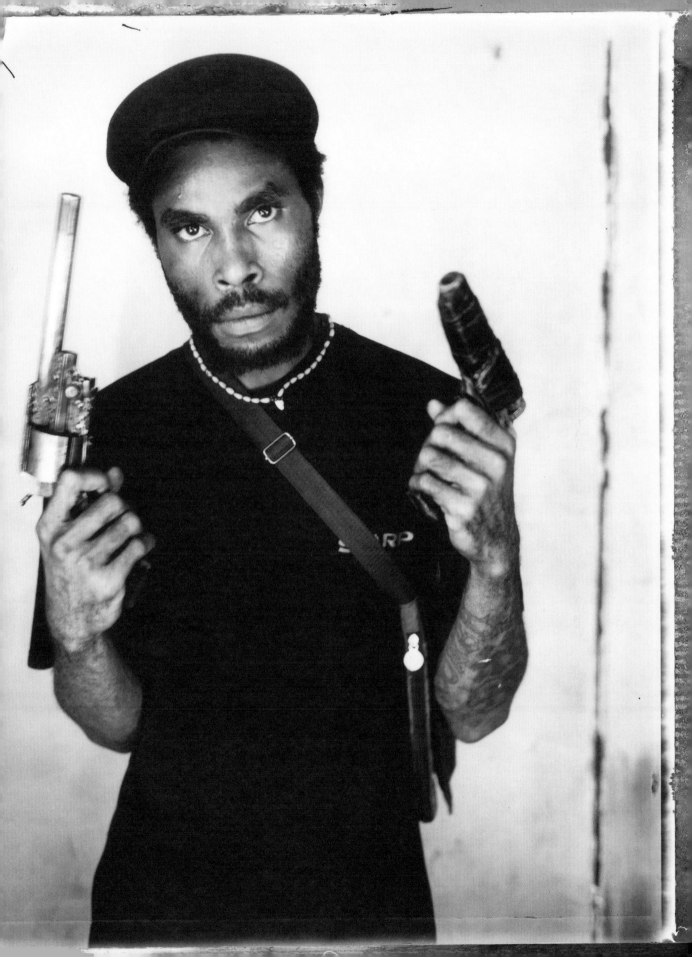

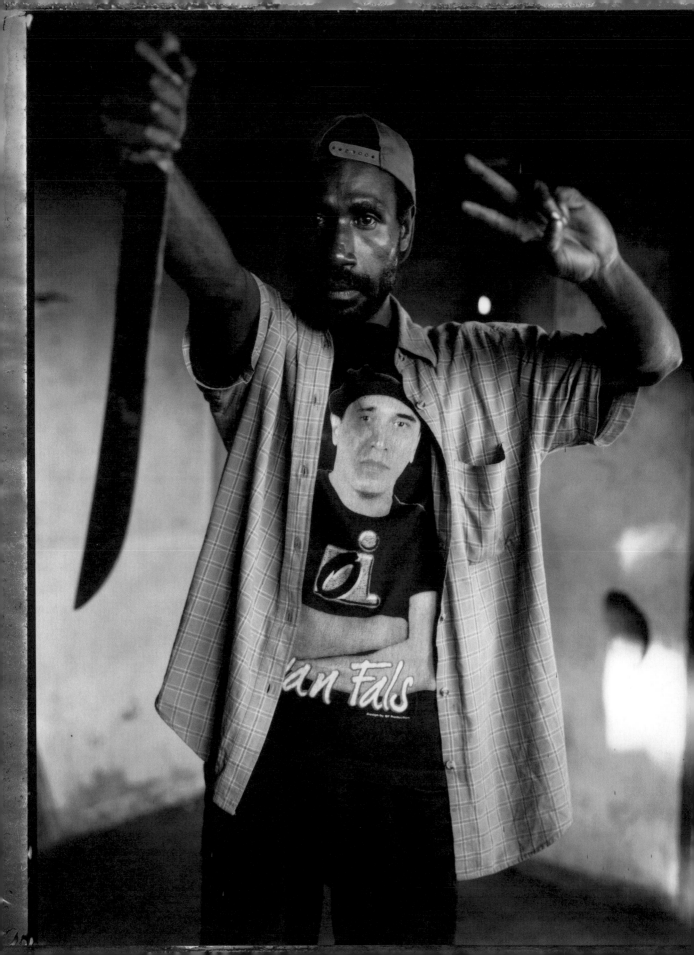

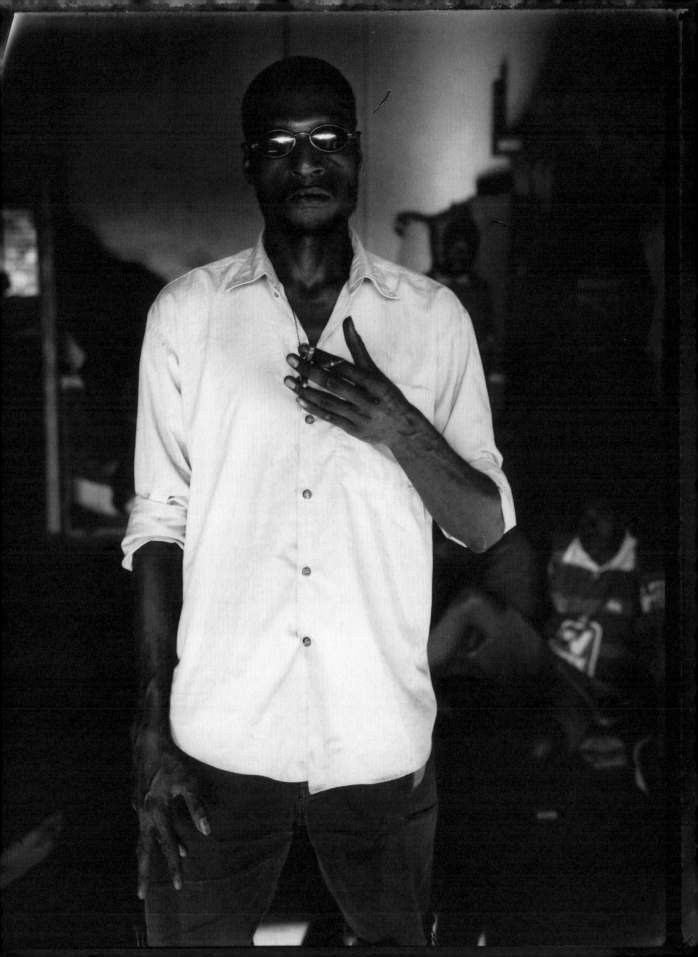

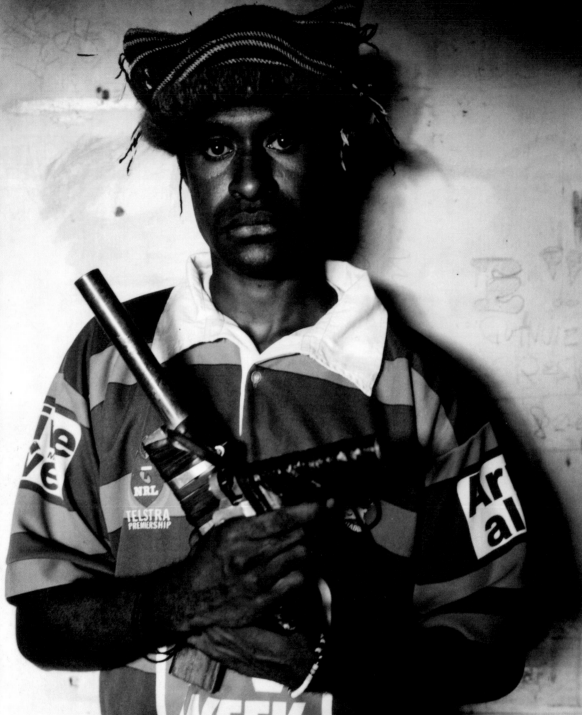

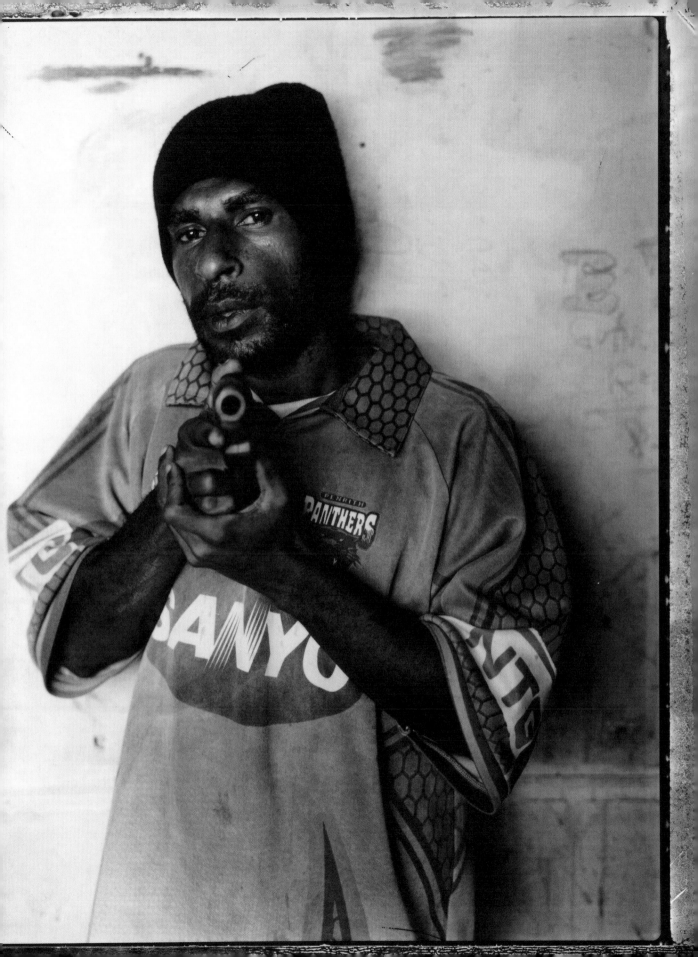

PS 91:1

HE WHO DWELLS IN THE
SECRET PLACE OF THE
MOST HIGH SHALL
ABIDE UNDER THE SHADOW
OF THE ALMIGHTY

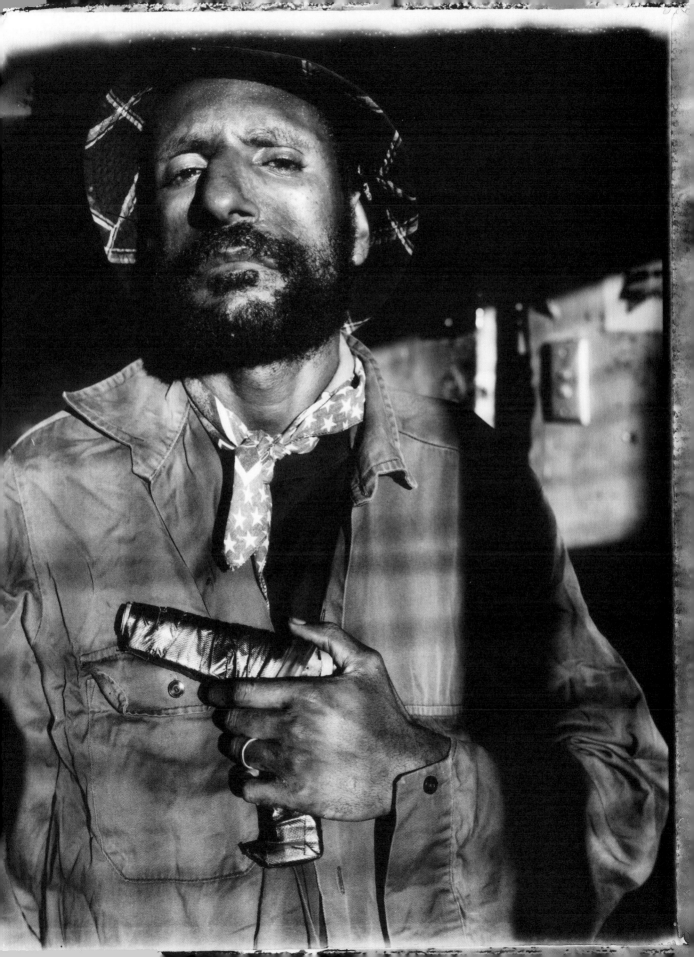

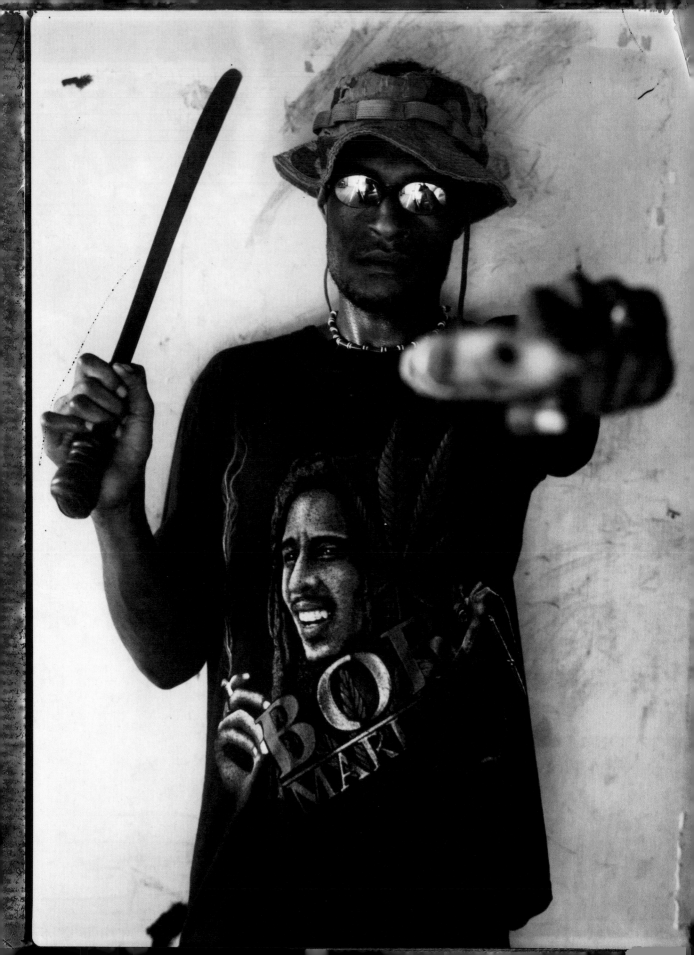

"WE'RE THE LITTLE RASKOLS, THE POLICE, THEY'RE THE BIG RASKOLS.

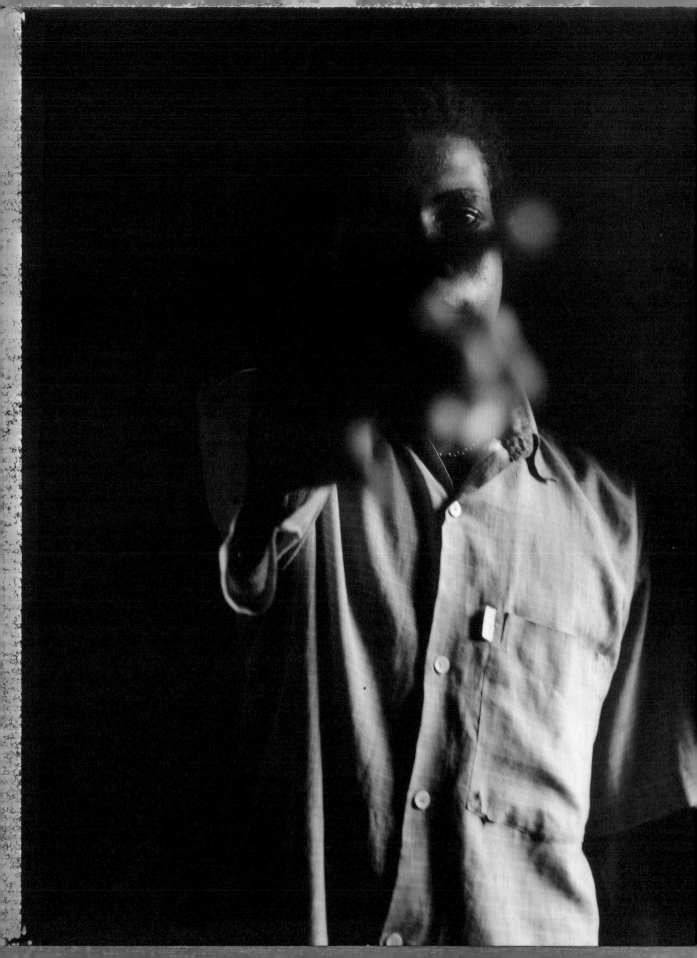

NO MAN IS
ABOVE THE
LAW
KOBONI RU

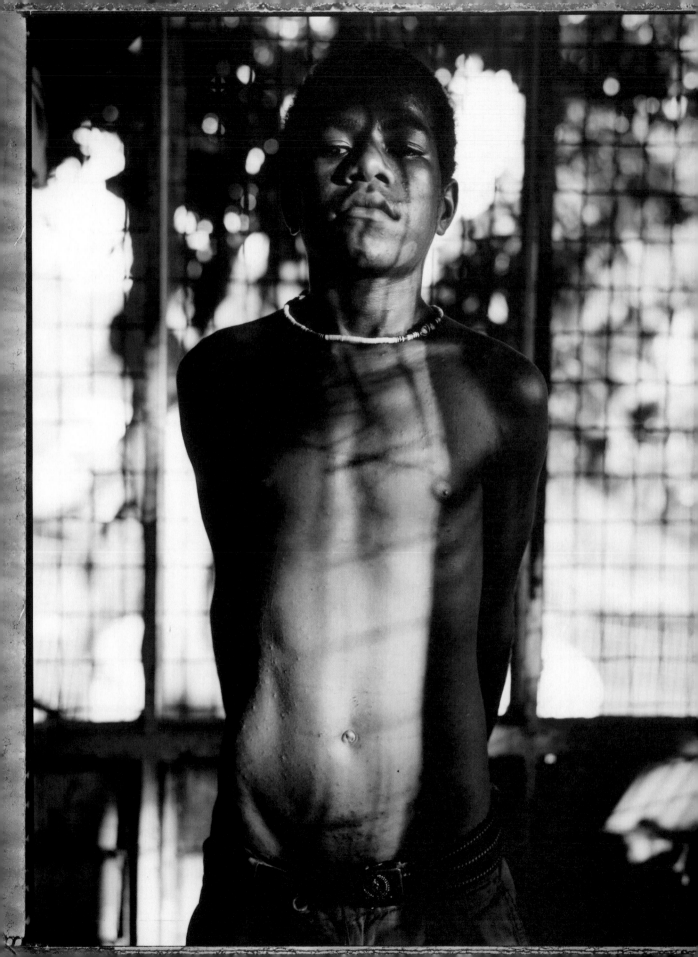

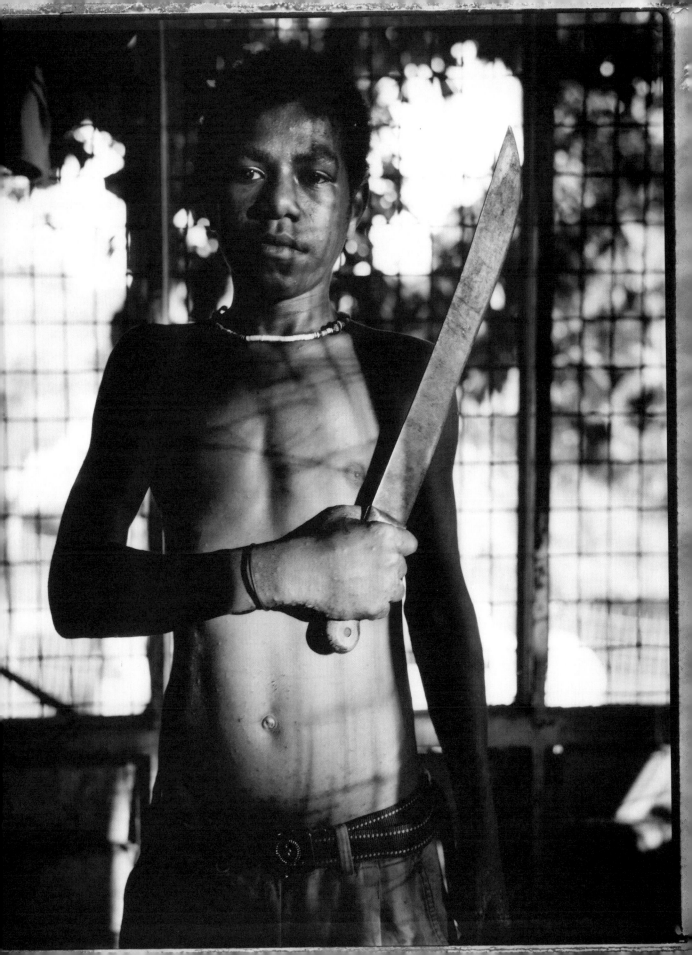

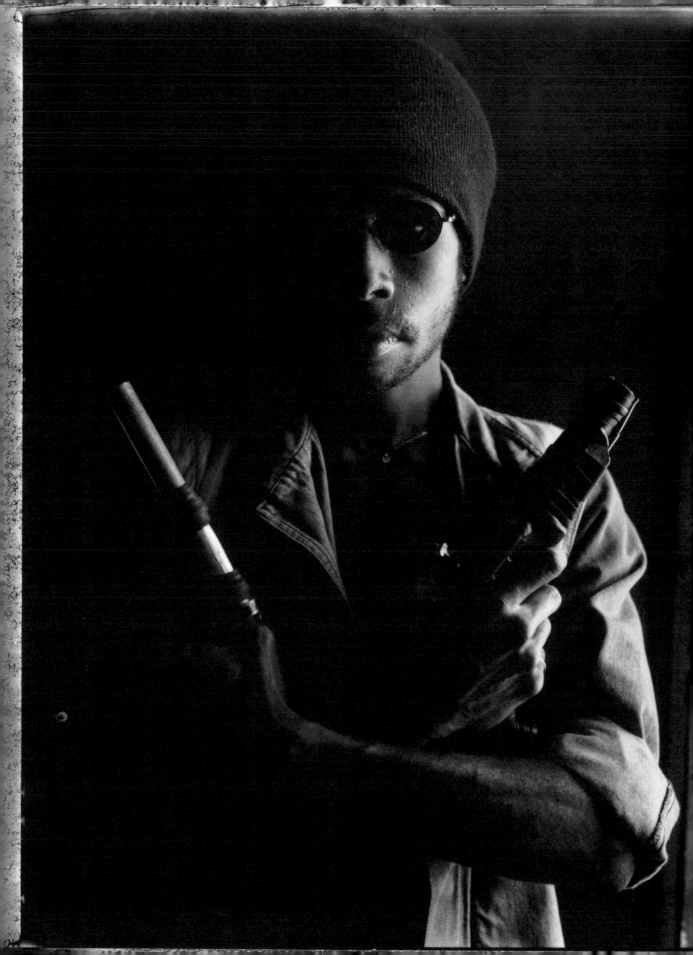

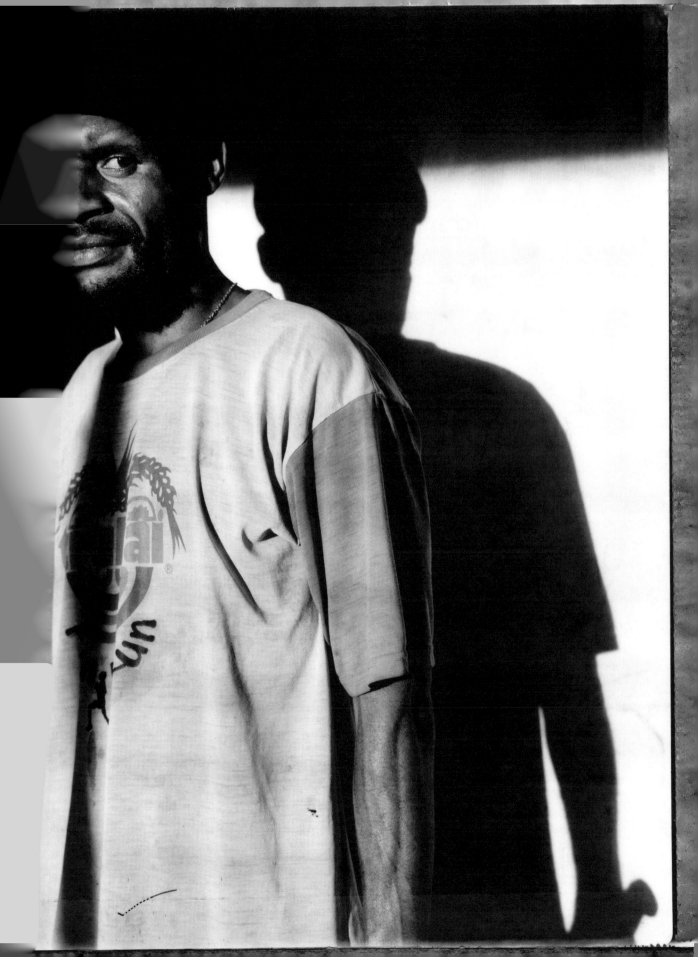

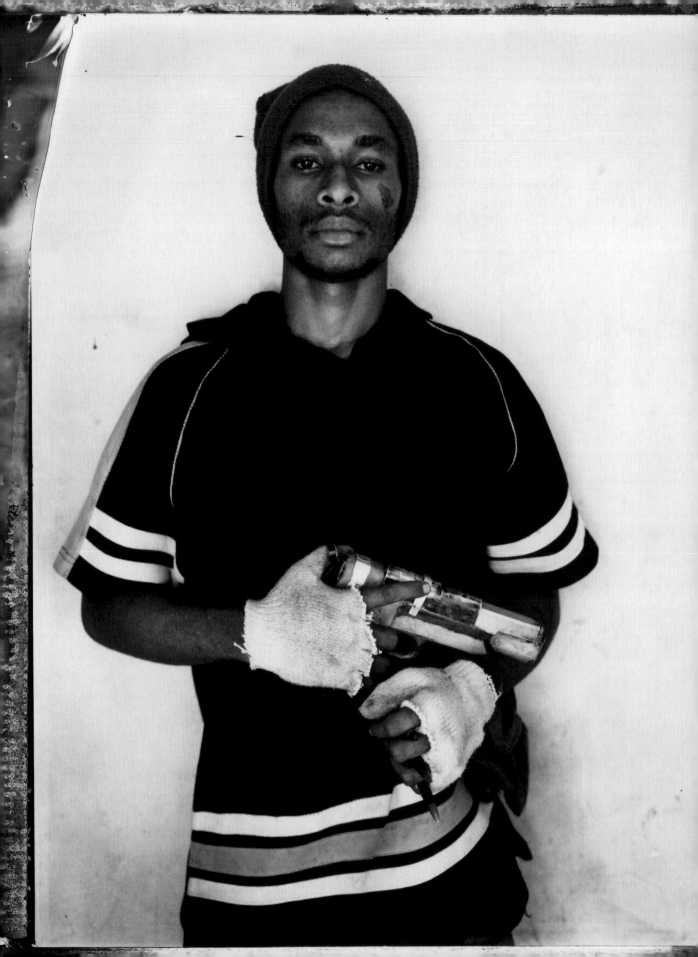

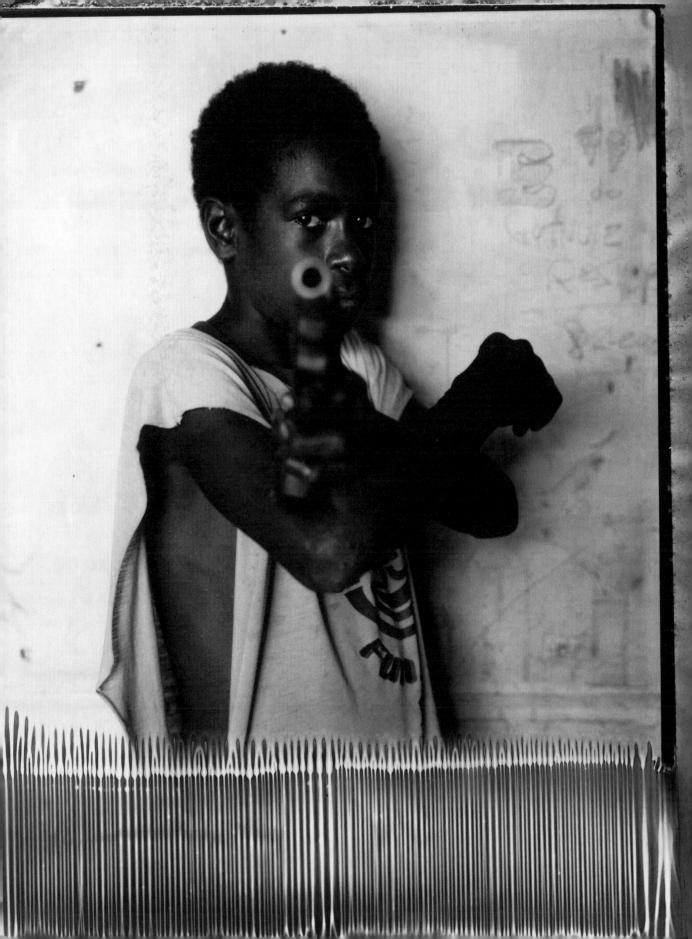

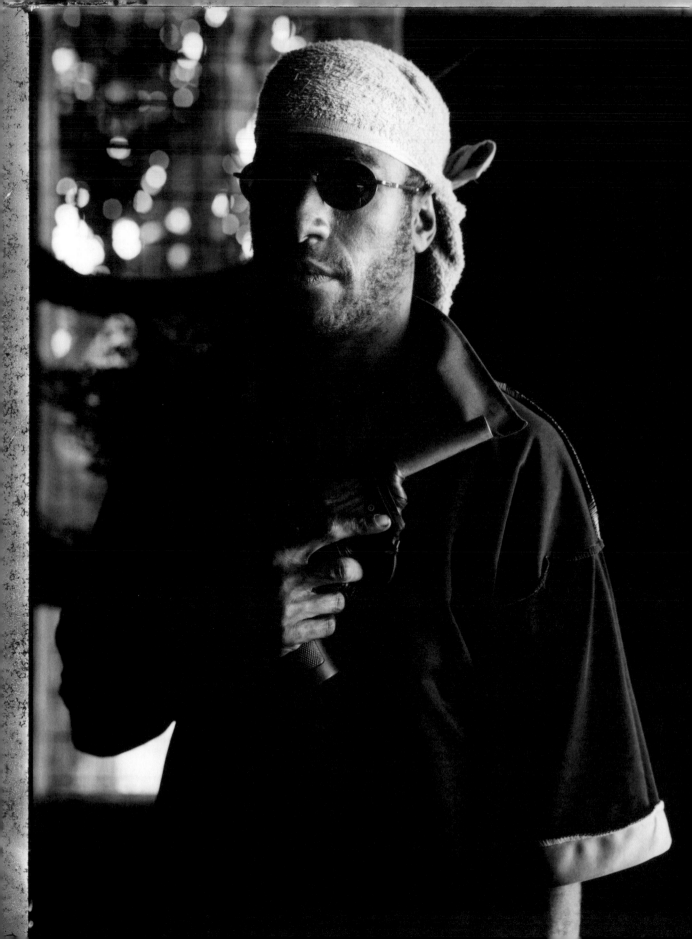

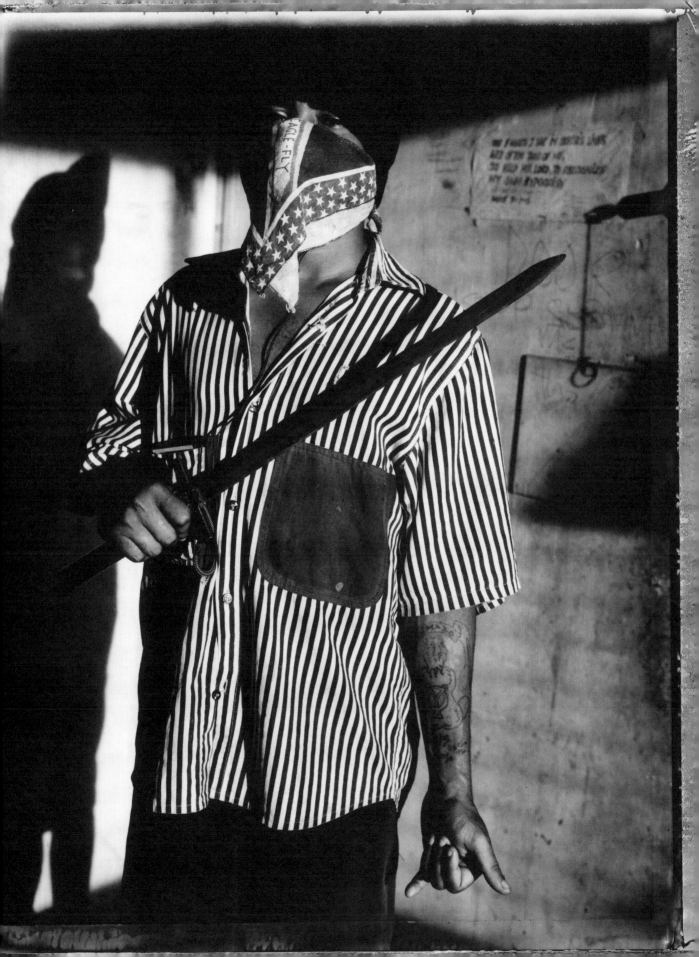

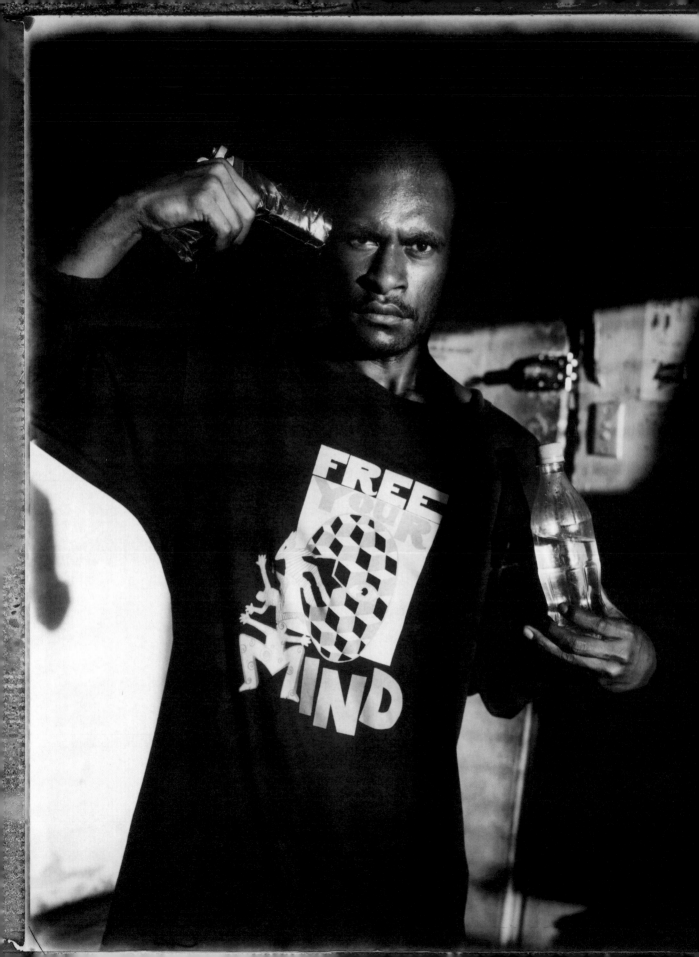

"I TRIED TO WALK THE PATH OF JESUS BUT IT WAS NO GOOD; THERE WAS NO CARGO, NO WORK, NO GIRLS. NOW i TRAVEL THE ROAD OF SATAN AND iT iS MUCH BETTER."

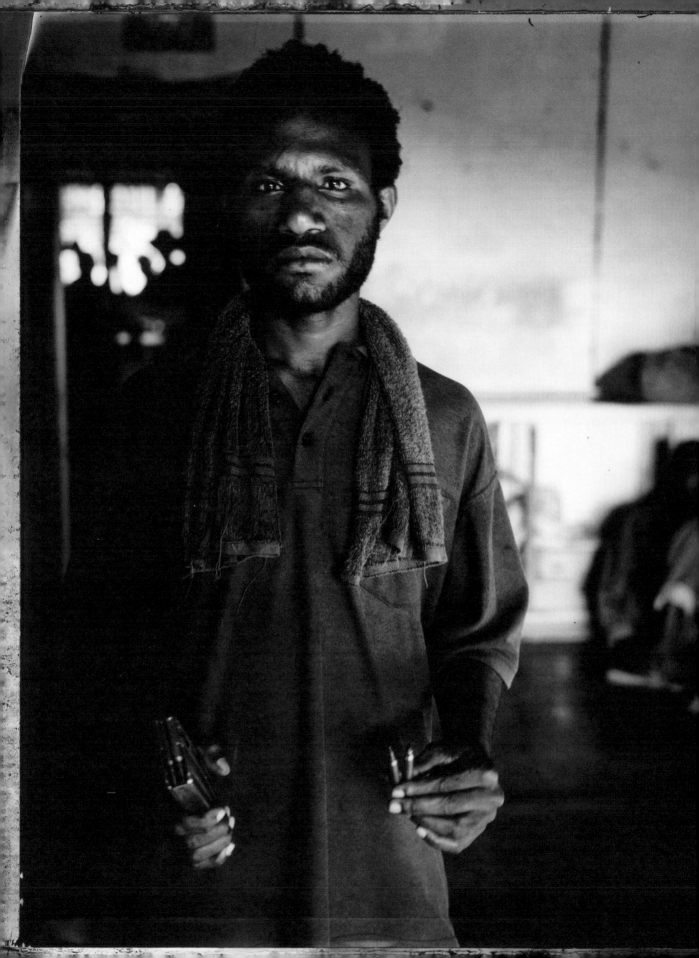

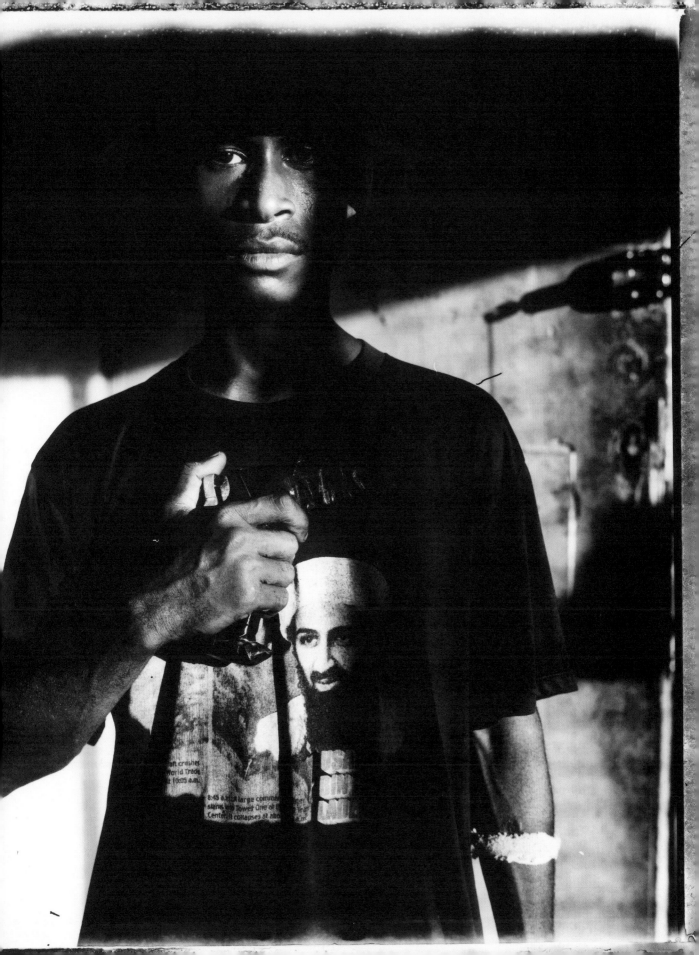

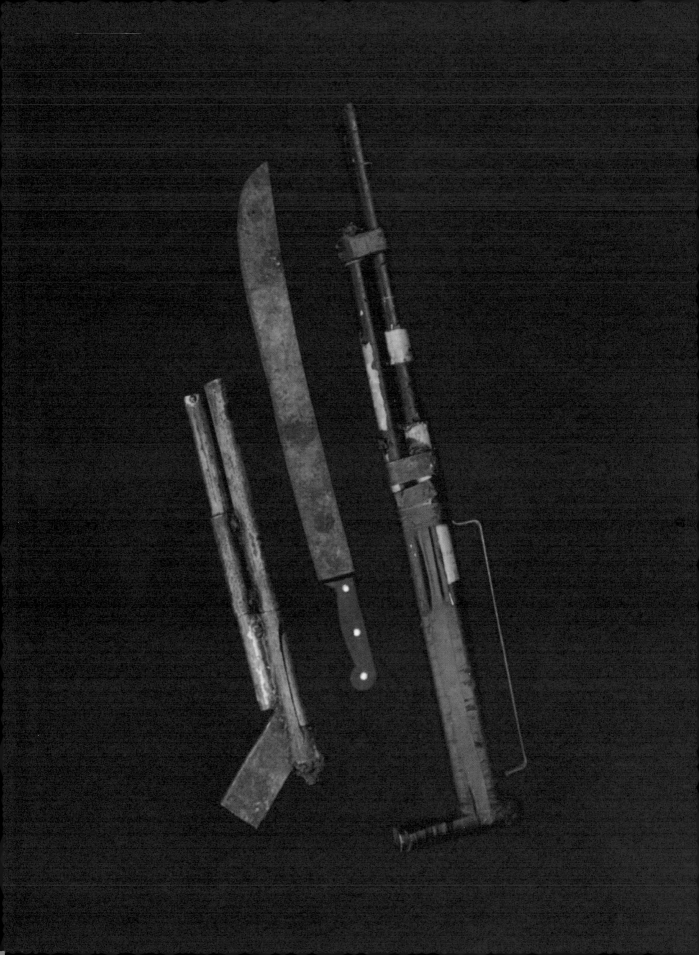

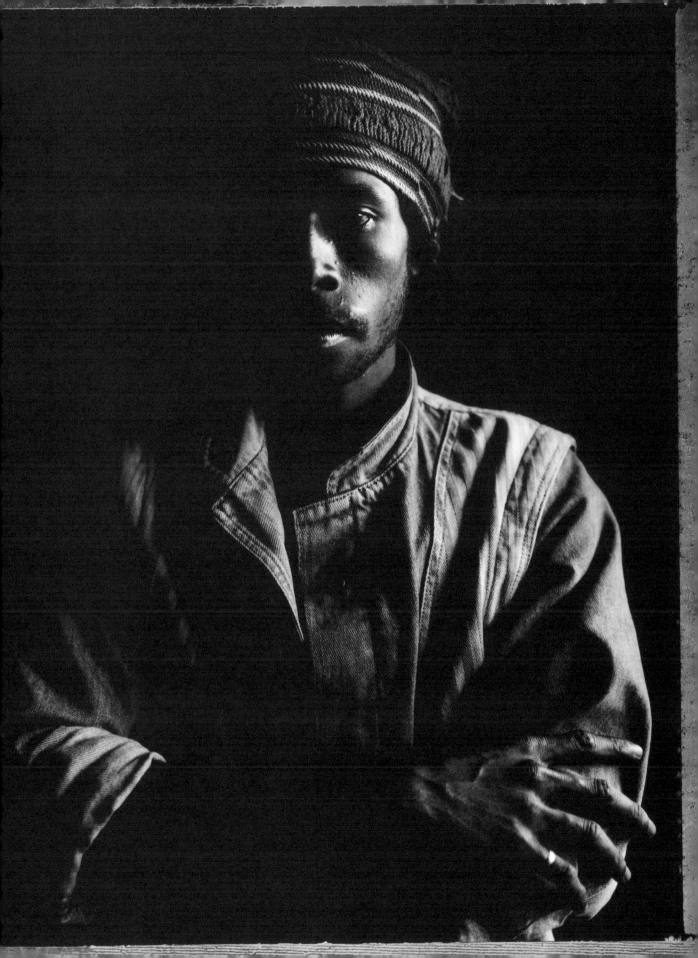

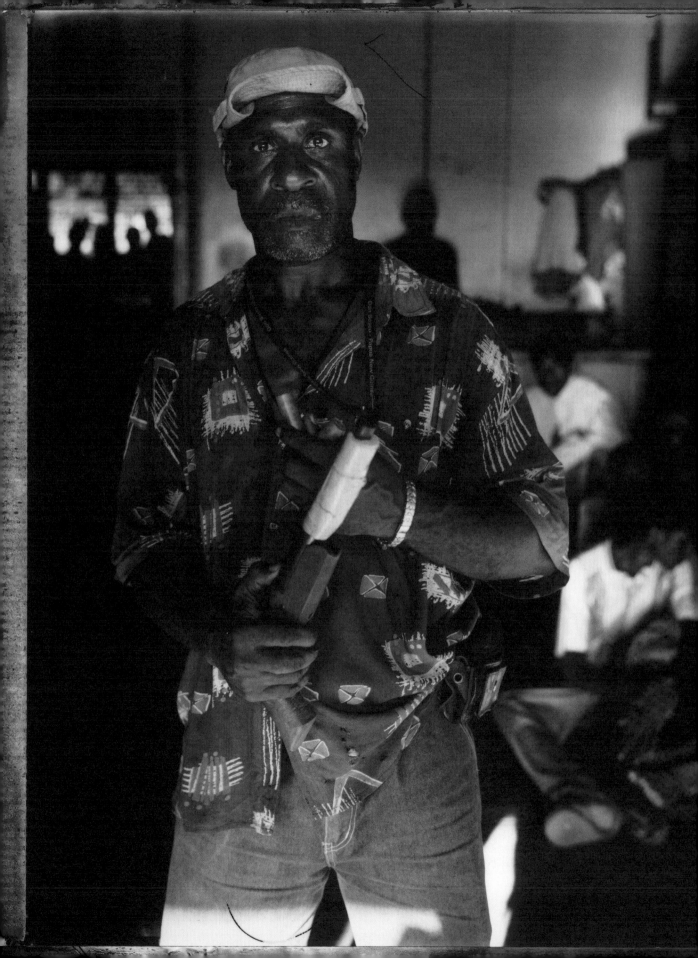

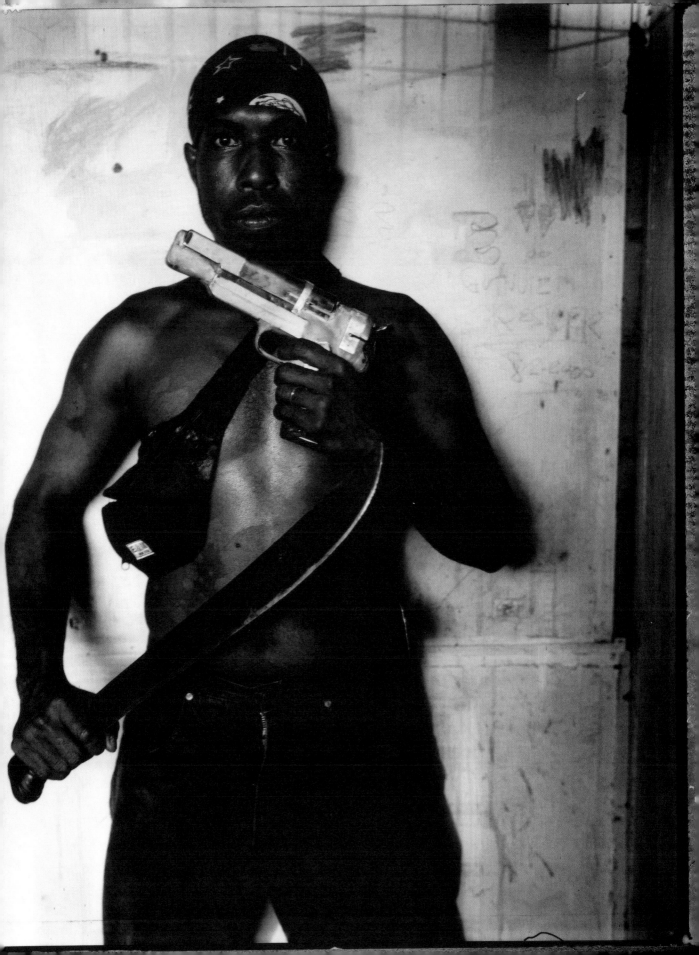

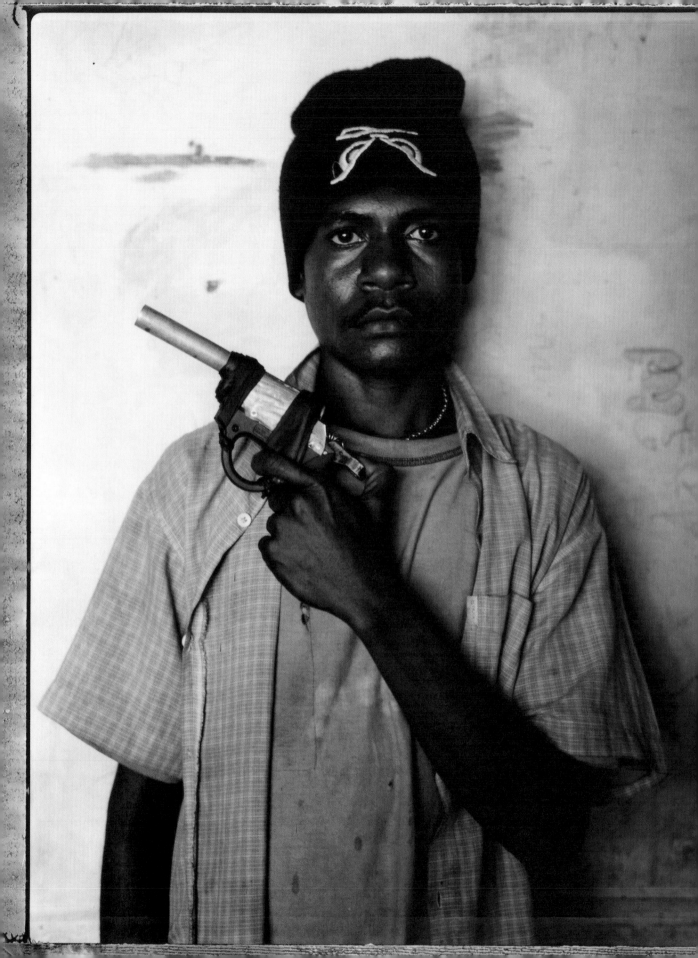

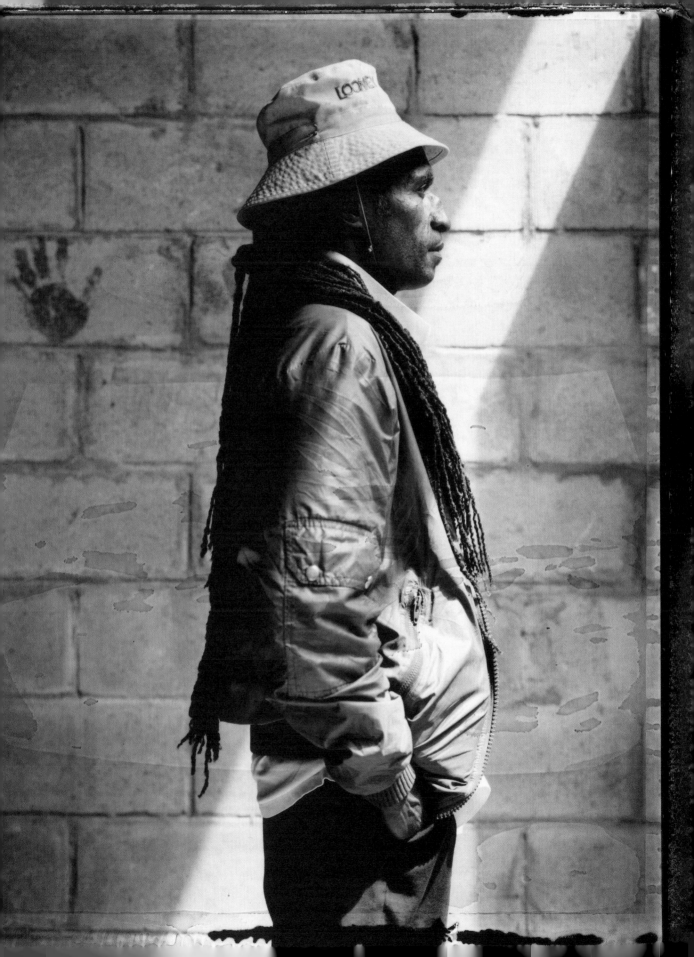

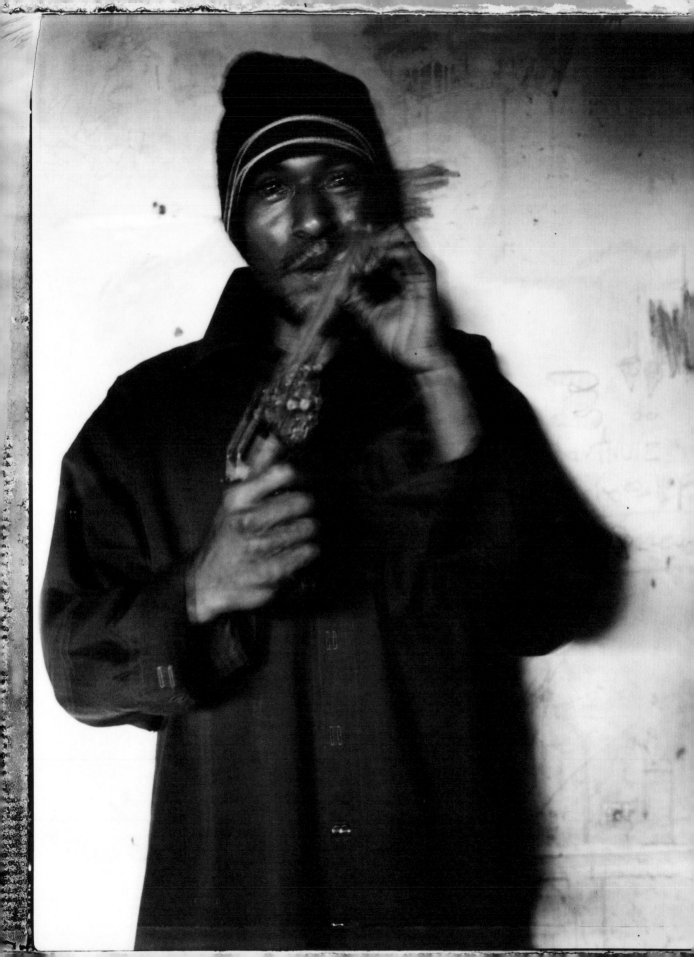

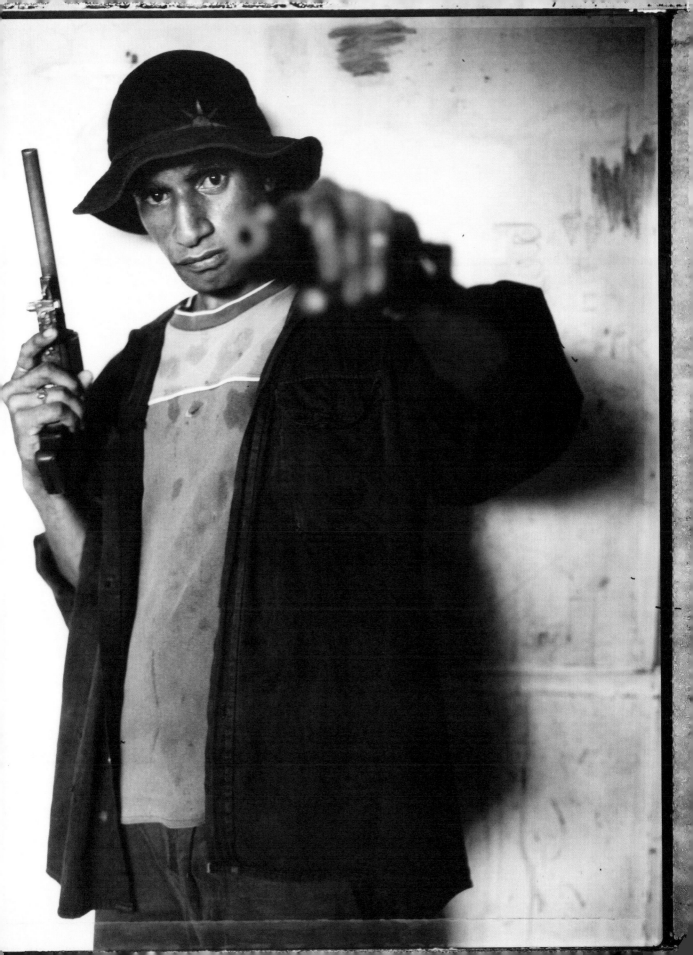

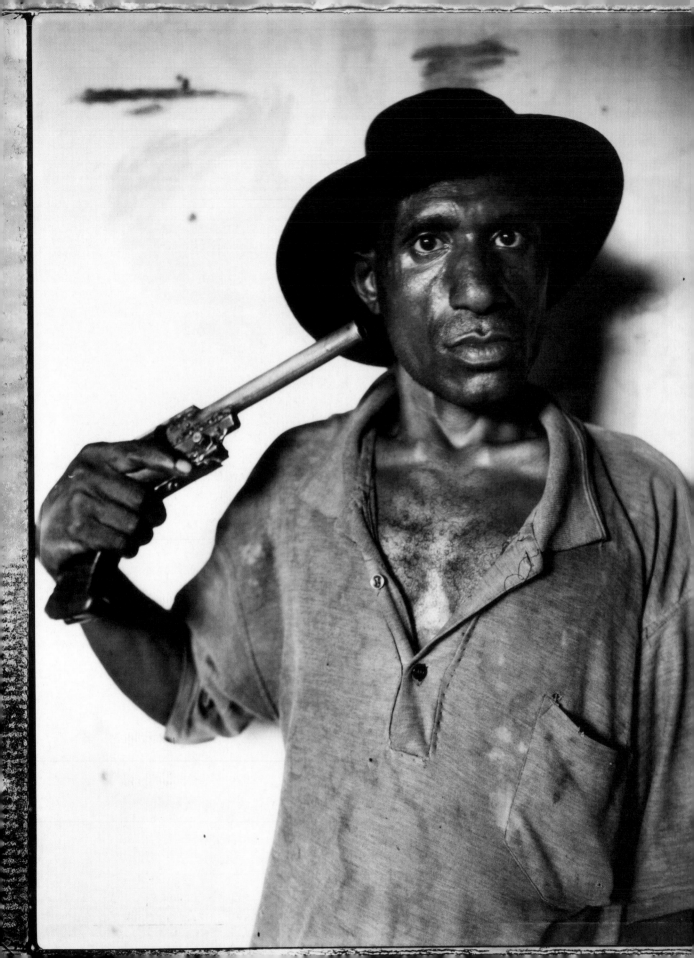

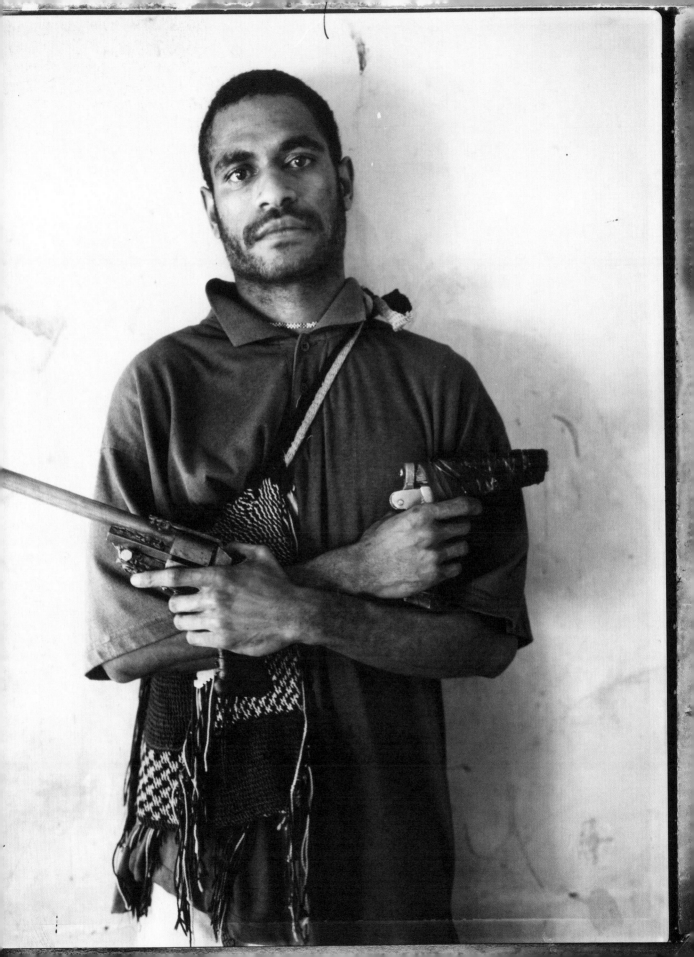

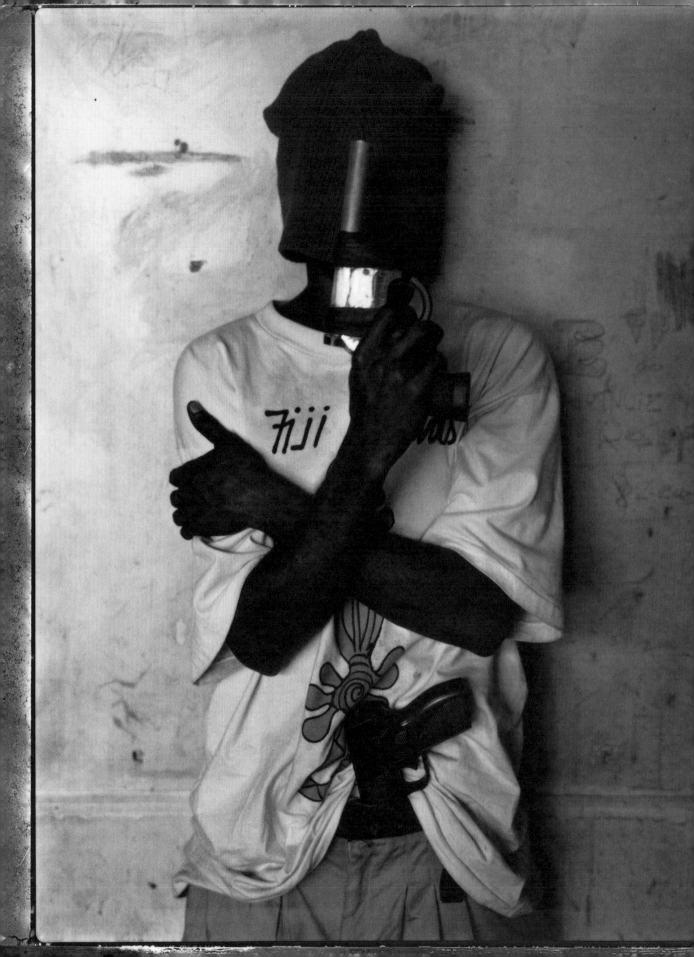

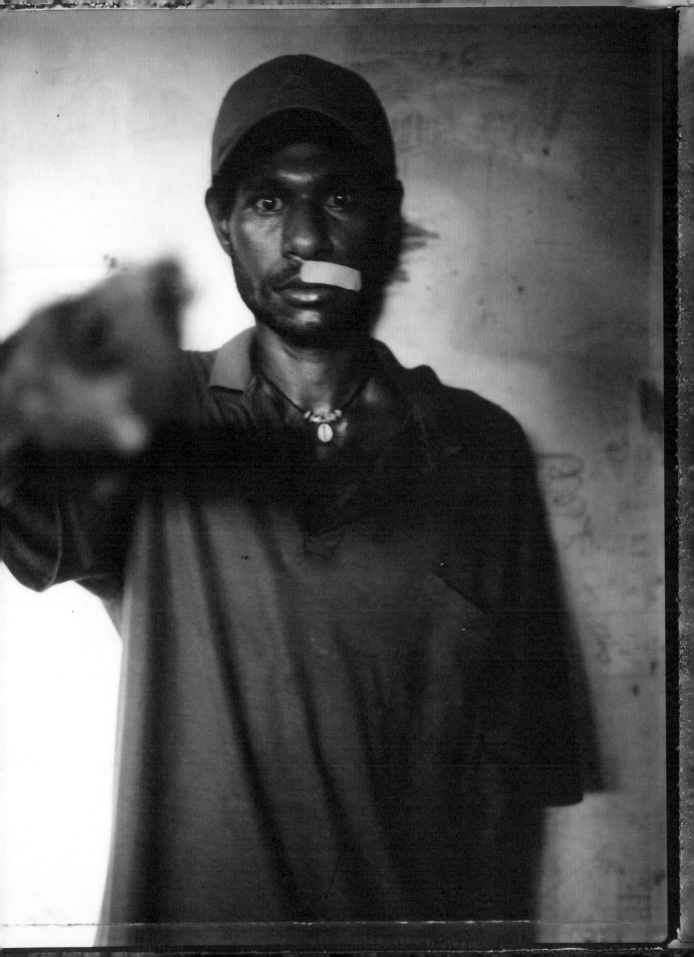

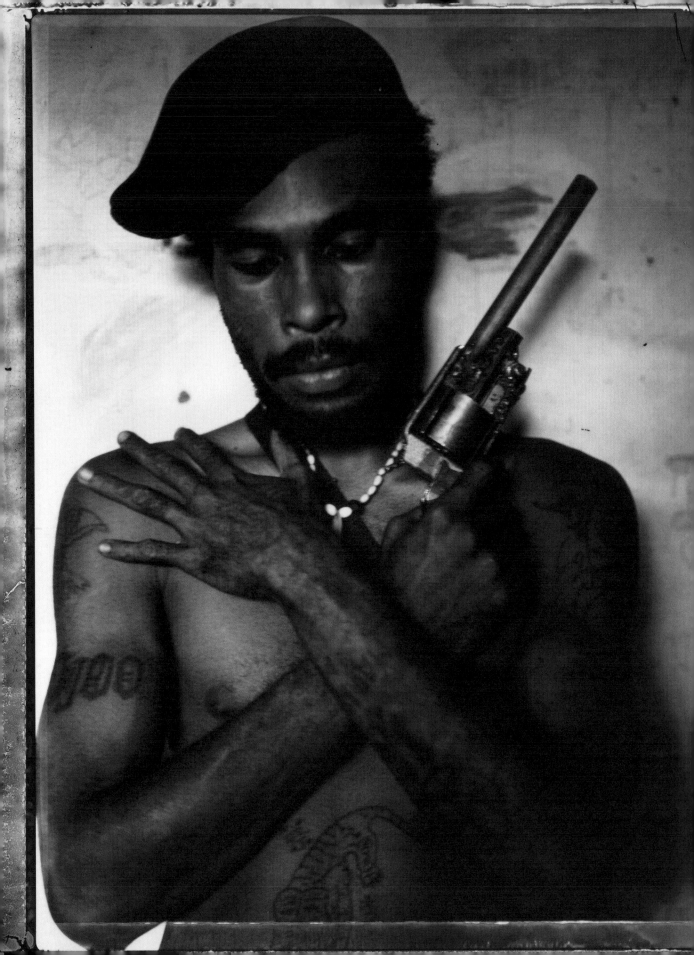

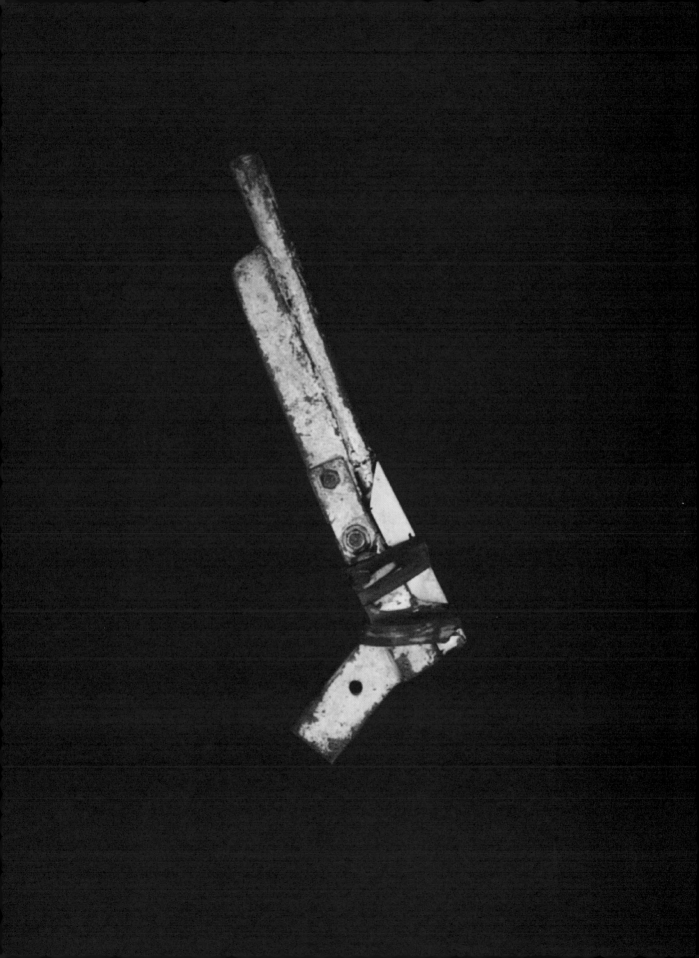

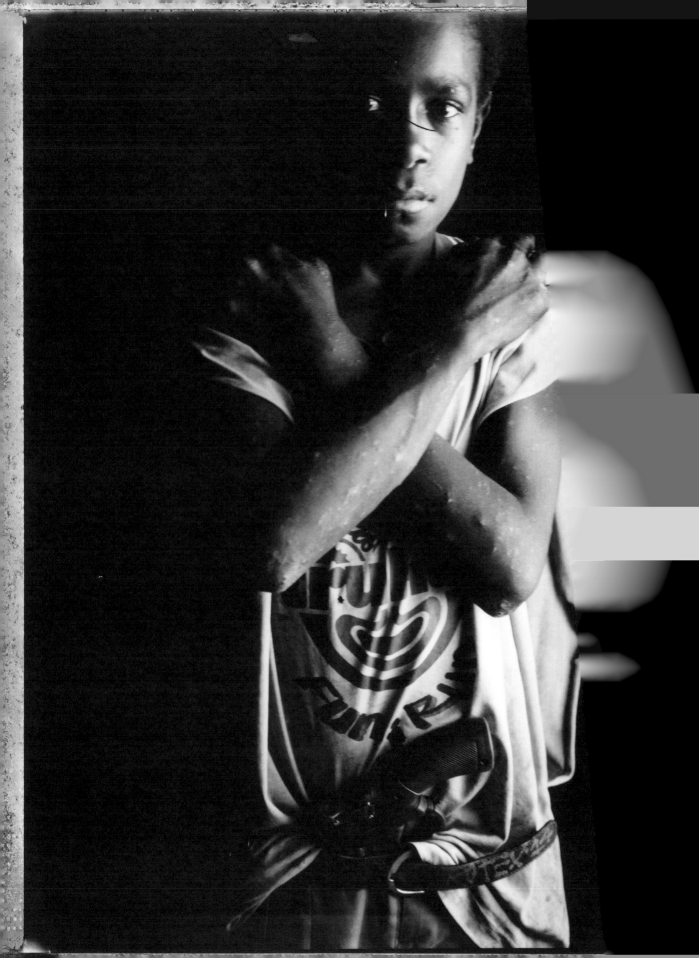

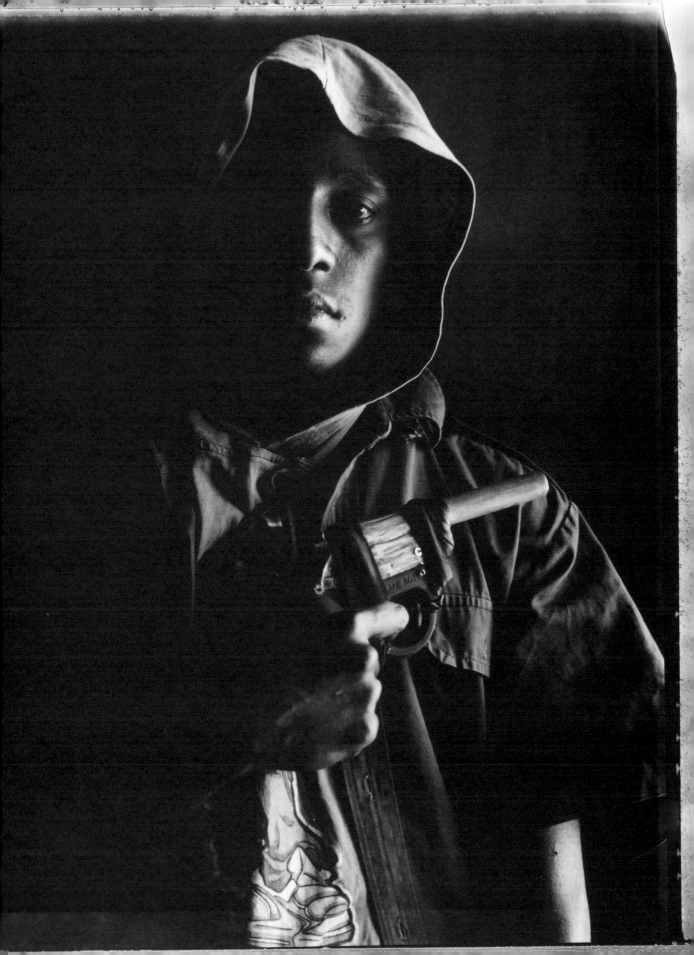

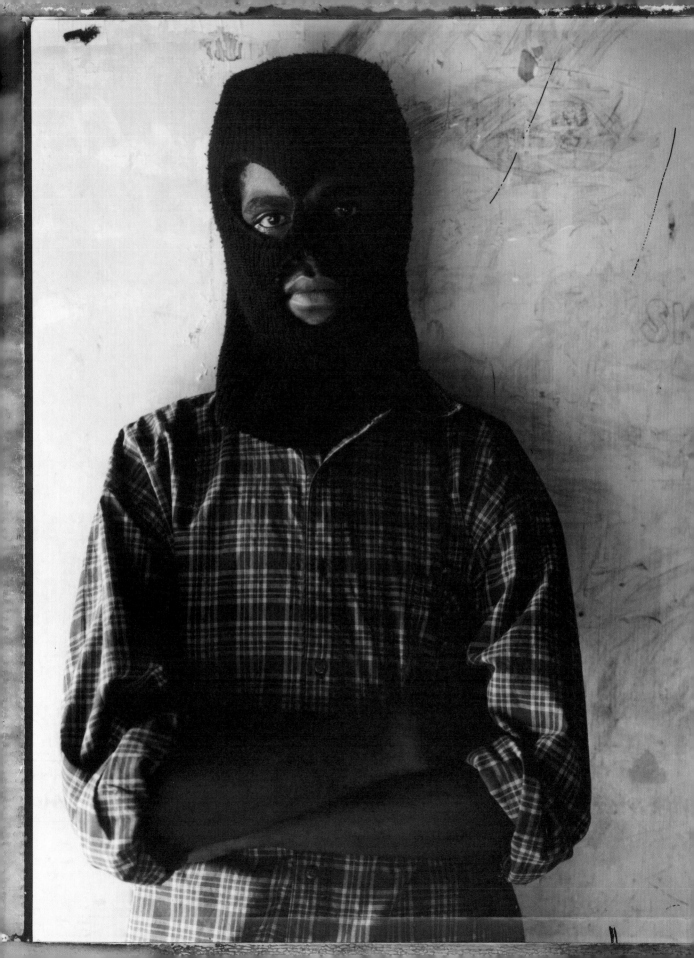

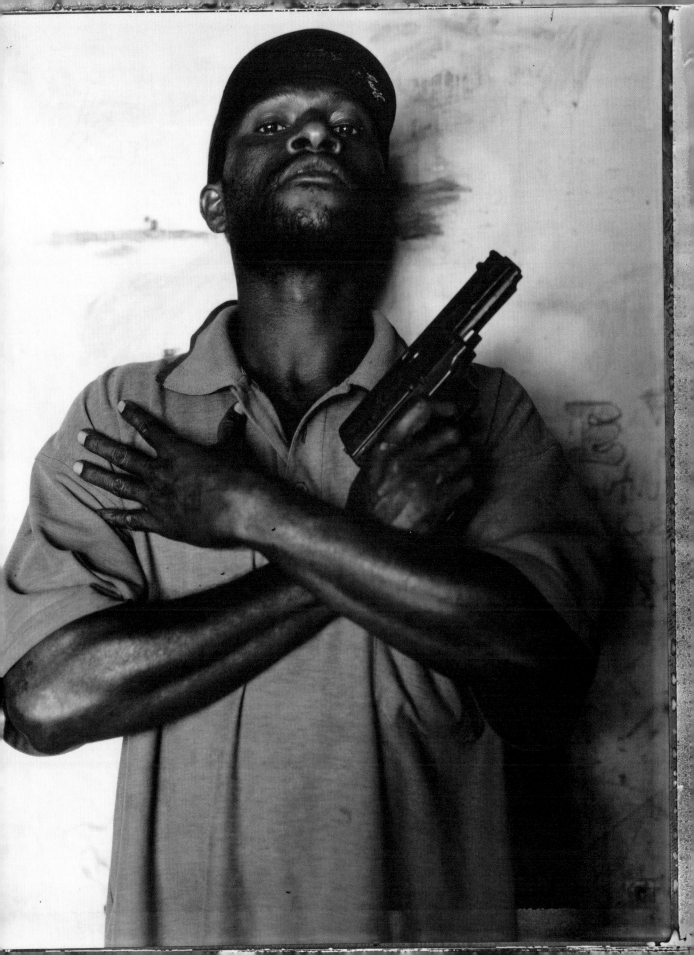

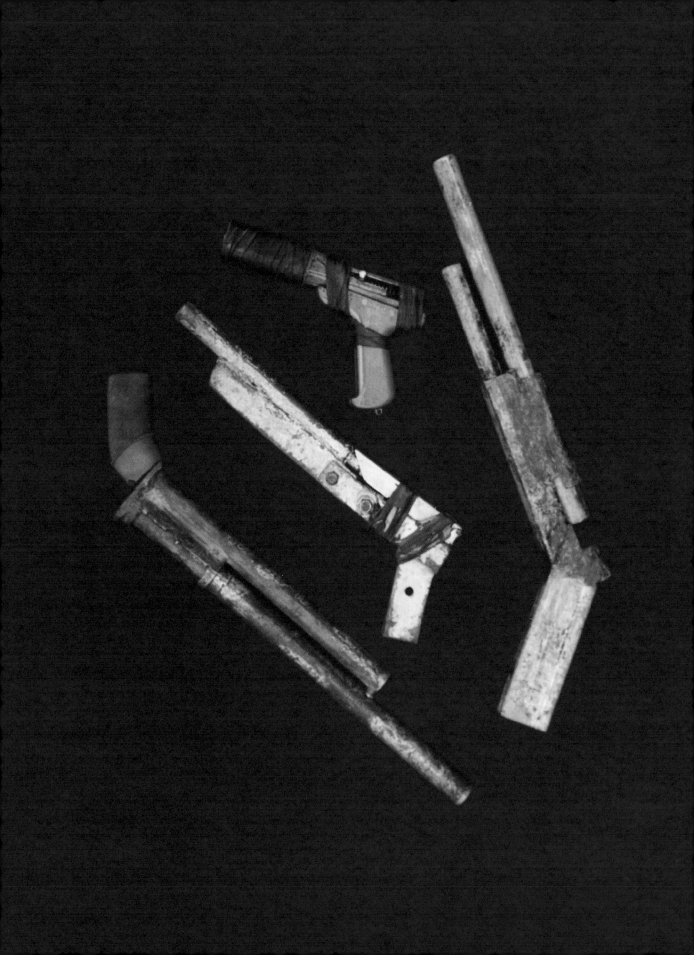

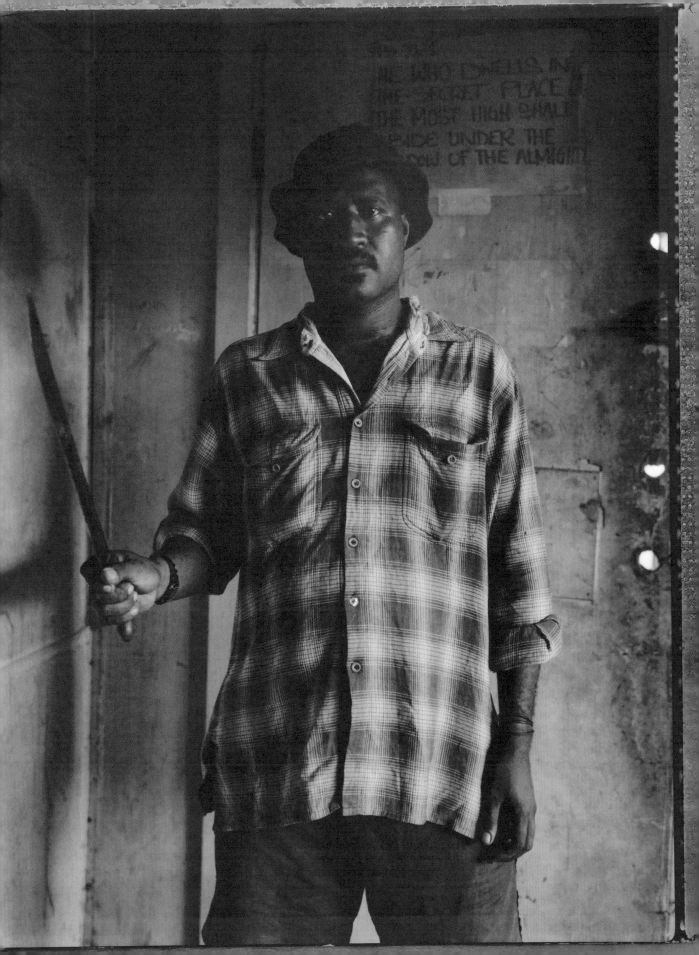

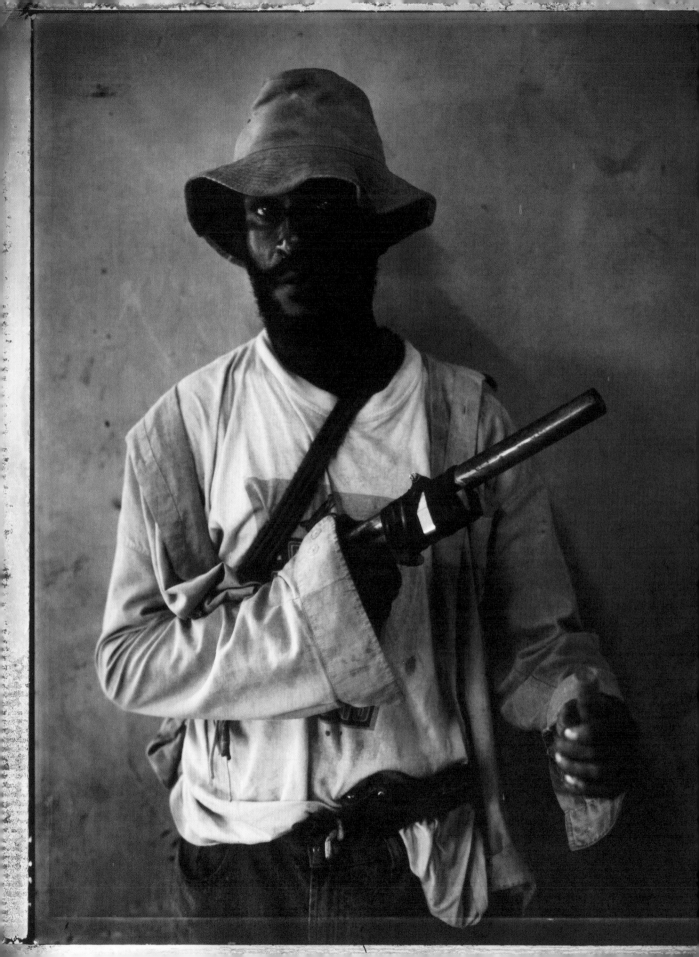

MAT 7:1-5

THE FAULTS I
SEE IN OTHER'S
LIVES ARE OFTEN
TRUE OF ME, SO
HELP ME, LORD,
TO RECOGNIZE MY
OWN HYPOCRISY.

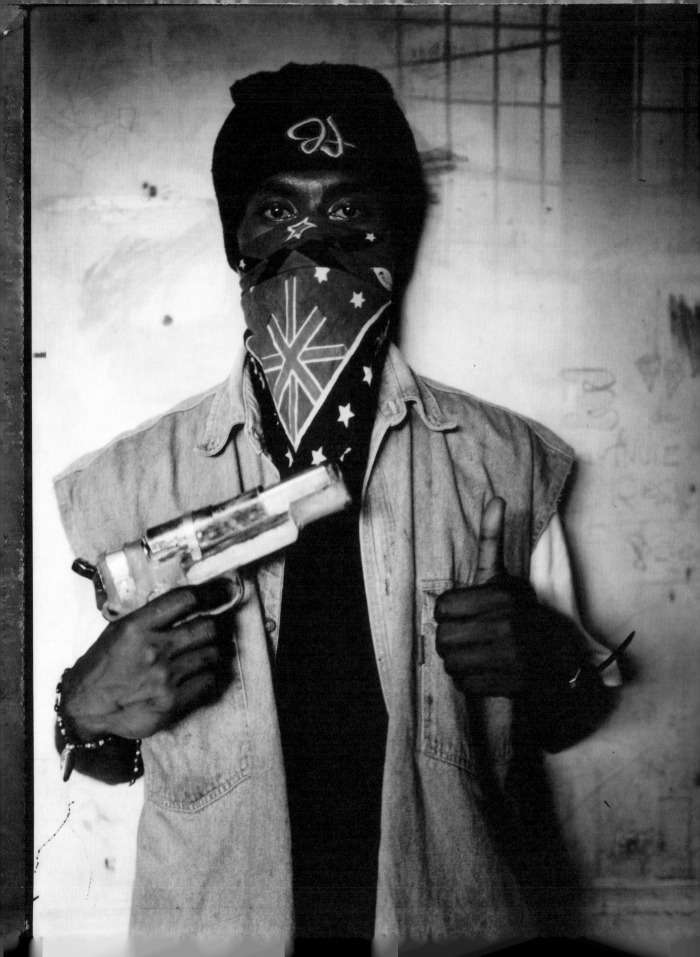

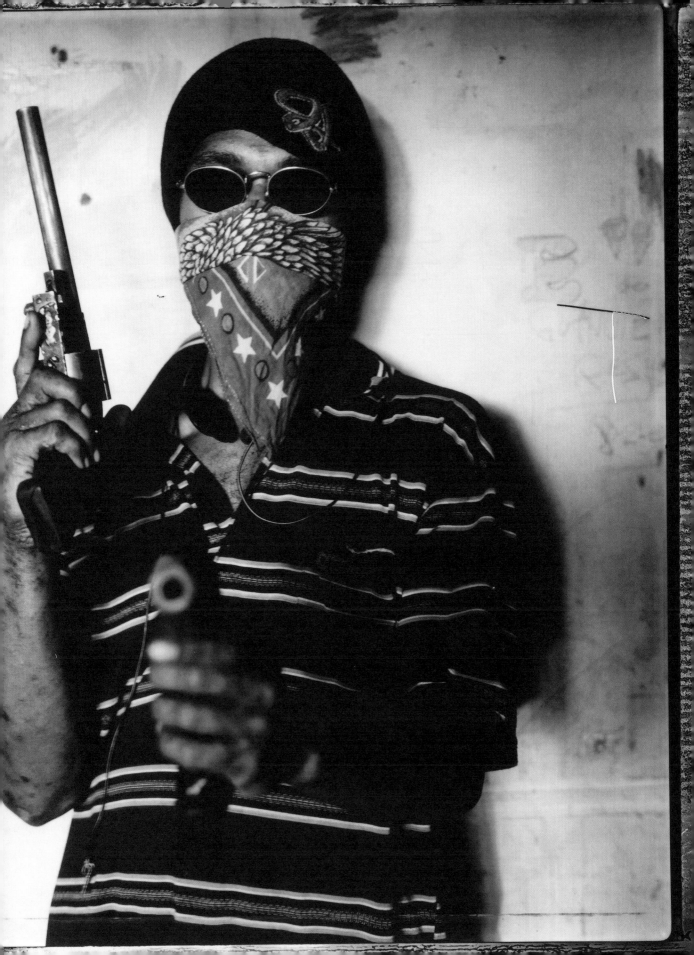

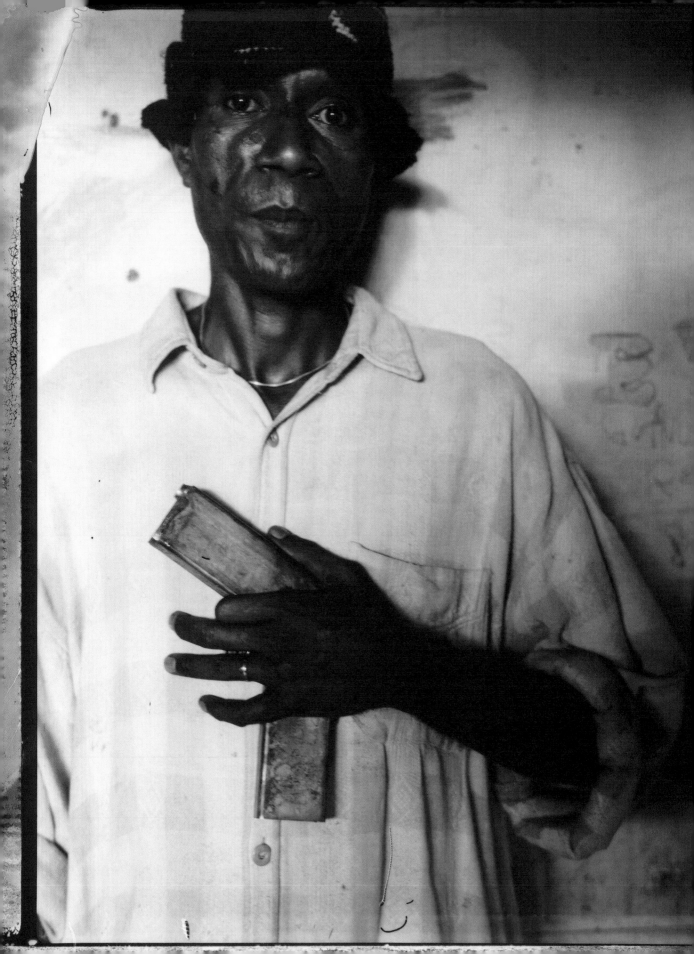

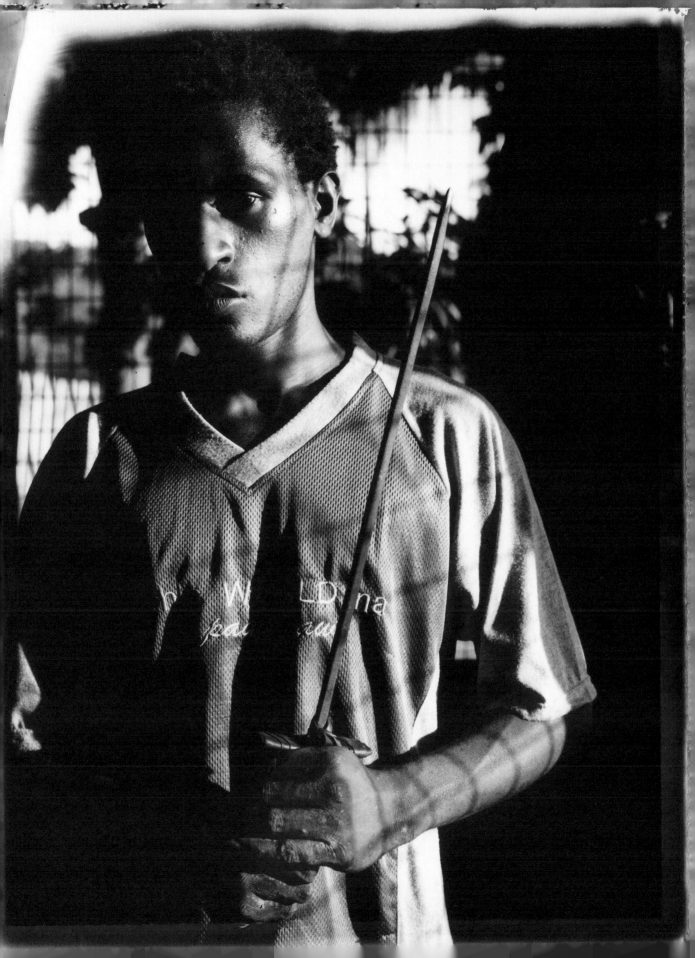

KIPS KABONI ARE:

ALLAN (THE GENERAL) OMARO, TYSON
N: DYX: BYSO, UFASAI, AKO, AIKARI,
CHRIS, IVINI, JOPS, DAISON, JAYFO,
ELOS, DIXON, MOGII, SHOOKMAN
OMSY, TRAPS, PNG, ANDY KEI, AITA
GAITZMAN, BILISO, EDDIE, ANDY
AMEX, BLACKANT, KAUGERE
TEIKS, JOHN FIVE R BMX, RAY
FATMEN, LUKAS MANIA, GHOST
SAMPSON MAIPE, TREPS, KOISE
ROCK, KAUSI, EDWARD, FORTY
OR GIDSY, DANNI, EVAVI, SOCKS

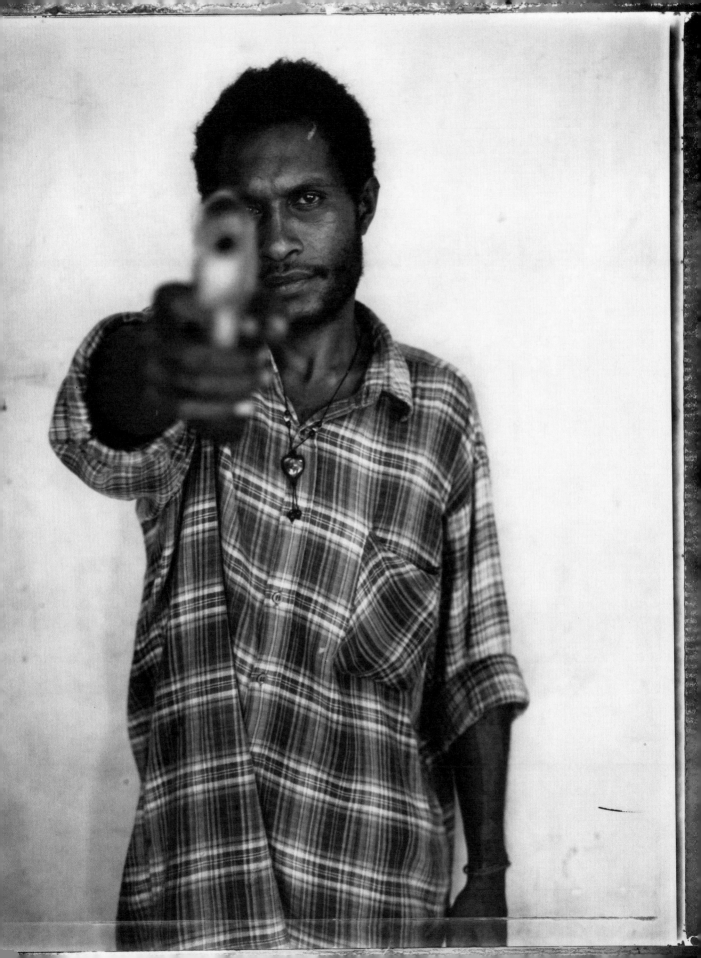

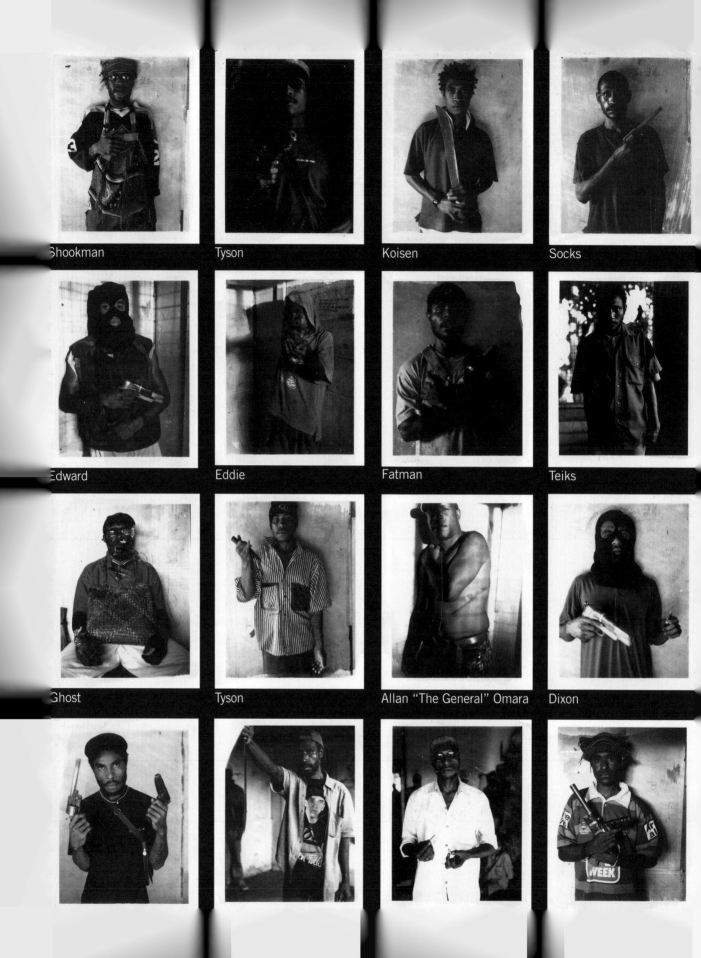

Shookman

Tyson

Koisen

Socks

Edward

Eddie

Fatman

Teiks

Ghost

Tyson

Allan "The General" Omara

Dixon

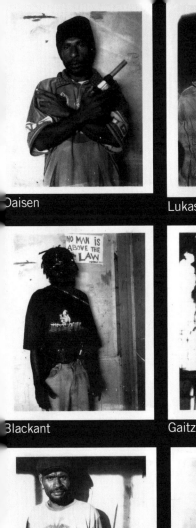

Daisen

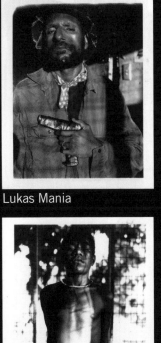

Lukas Mania

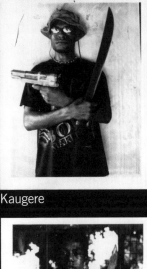

Kaugere

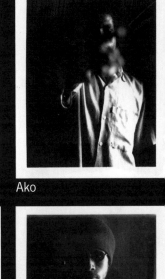

Ako

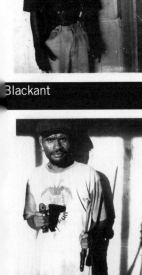

Blackant

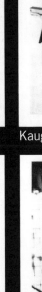

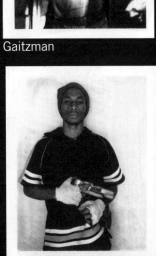

Gaitzman

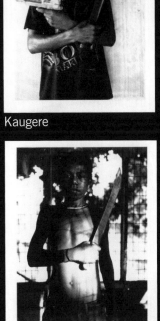

Gaitzman

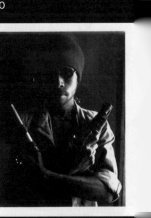

Jay Fox

Aita

Evavi

Mogii

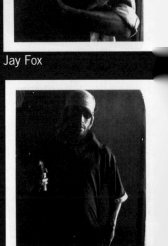

Dixon

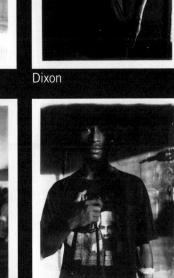

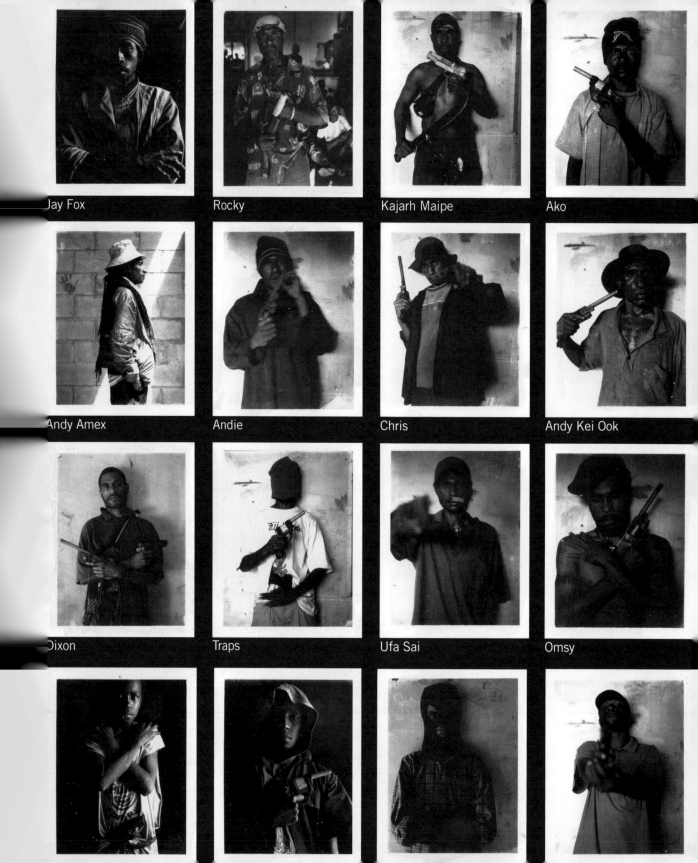

Jay Fox

Rocky

Kajarh Maipe

Ako

Andy Amex

Andie

Chris

Andy Kei Ook

Dixon

Traps

Ufa Sai

Omsy

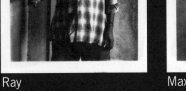

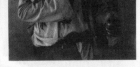

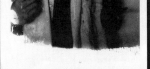

Ray

Max

John Fivir BMX

Larry Joe

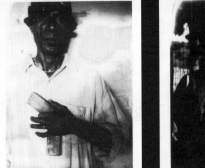

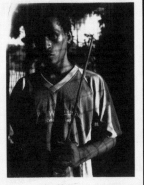

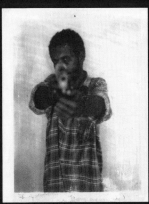

Mogie

Or Gidsy

Samson Maipe

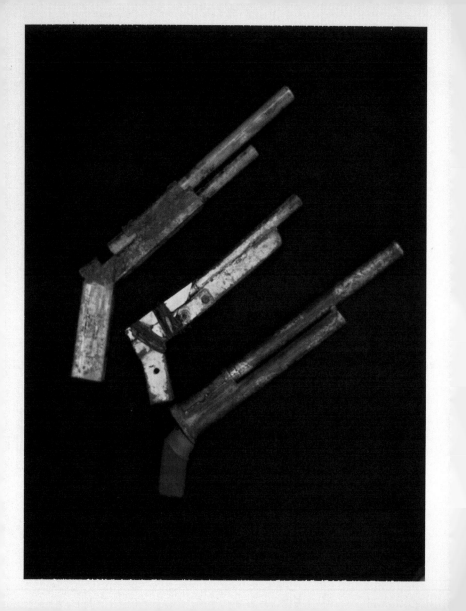

AFTERWORD

7 Years Later

In 2011, I decided to track down the original Kaboni boys from 2004.

With Allan Omara's help, I was able to find many of the raskols I had photographed. I brought with me the original Polaroids in a small stainless steel box and showed them to Allan. Holding the photos like a deck of cards Allan threw them down one by one, commenting along the way:

"He's still around, he's a drunk, he's still here, he's dead, he's in gaol, he moved to the gulf back to his village, he's now working as a gardener, he's a security guard, he's on trial for rape, he was murdered during an armed hold up, he's still active in the gang, he can be found behind the footy field drinking home brew, he's on drugs...."

I was both surprised and happy to hear that many I met were no longer active raskols, instead working as labourers, or security guards. Some had found God or joined a rock band. Some declined to see me, others were just not available or had moved away. At least four are dead.

> Jay Fox is 32 years old. He works as a security guard with G4S Security Company in the G4S Elite Unit. He has guarded the offices and homes of United Nations staff in Port Moresby.
>
> Mosco is 27 years old. He is unemployed and still an active member of Kips Kaboni.
>
> Jops is 26 years old. He is unemployed and still an active member of Kips Kaboni.
>
> Shookman was 27 years old. He was shot in the head and upper body during an armed robbery attempt of a Chinese owned trade store in Port Moresby. He is buried at 9 Mile cemetery on the outskirts of the city. He was a representative of the national Papua New Guinea basketball team.
>
> Aita died in 2005 of tuberculosis. His unclaimed body lay at Port Moresby General Hospital for six months before he was buried in a mass grave alongside other unclaimed bodies at 9 Mile Cemetery. He was a funny guy, well loved, the community clown, and was HIV positive.
>
> Traps is 41 years old. He is in Bomana gaol on suspected abduction and rape charges committed in November 2010. He was working as a security guard with

Plus Security. His friends say he is innocent.

Max is 37 years old. He is a labourer with a construction company.

Tei is 39 years old. He is a labourer with a construction company.

Ufa Sai died in 2007 of Malaria in his village of Miaru in the Gulf Province.

James Ani is hiding somewhere.

Ivini has gone to live in Baimuru village in Gulf Province.

Andy Amex has moved to Baimuru village in Gulf Province.

Daisen moved to Gerahu settlement in Port Moresby.

Kausi is 35 years old. He is a security guard at 4 Square church.

Lukas Mania is 39 years old. He is a gardener at PNG Garden.

Teiks is 20 years old. He is unemployed.

Elos is 35 years old. He is a security guard at Plus Security Company.

Biliso is unknown to Allan and none of the other Kaboni boys know who he is.

Anori is 23 years old. He is a carpenter working for Sarco Timbers in 6 Mile.

James Nase is 23 years old. He is a maintenance worker at Port Moresby Country Club.

Rocky is in his 40's. He is working as a security contractor for BMobile tele-communications company.

Allan Omara is retired.

Stephen Dupont
Port Moresby, PNG
September 2011

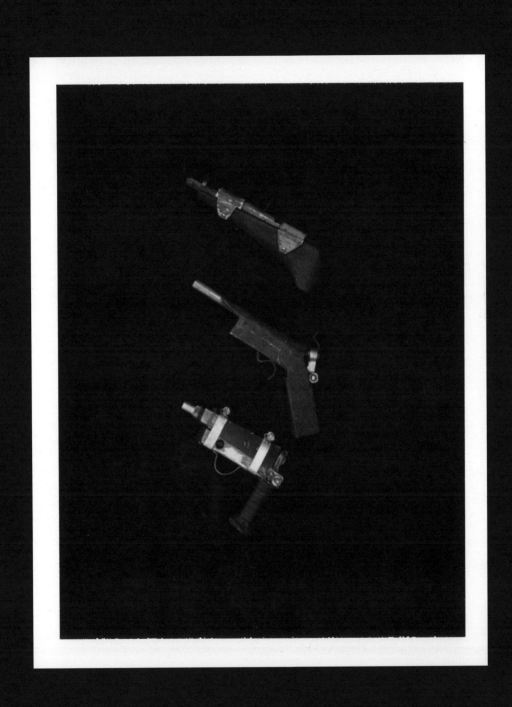

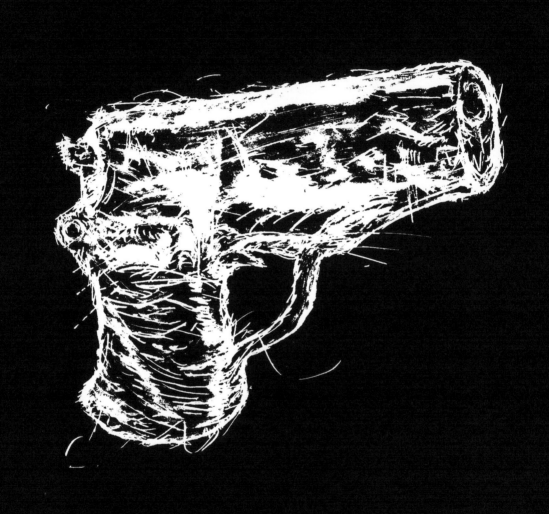

Stephen Dupont is an Australian photographer and filmmaker who primarily photographs fragile cultures and marginalized peoples. Recipient of the 2007 W. Eugene Smith Grant for Humanistic Photography and the 2010 Gardner Fellowship at Harvard's Peabody Museum for his work on Papua New Guinea, his photographs and handmade artist books are in the Collections of The Library Of Congress, The New York Public Library, and the National Gallery of Australia, among others. He is a member of the New York-based agencies Contact Press Images and Booklyn Artist's Alliance. Dupont lives with his family in Austinmer, Australia.

Ben Bohane is an Australian photojournalist, television producer, and author. For more than 20 years he has covered religion and war throughout the Asia-Pacific region. He has worked for many of the world's major media outlets including Vanity Fair, Time, French GEO, and a variety of Australian publications and broadcasters. Since 1994 he has specialized in the Pacific Islands, documenting Kastom, cargo cults, and other religious movements in Melanesia.

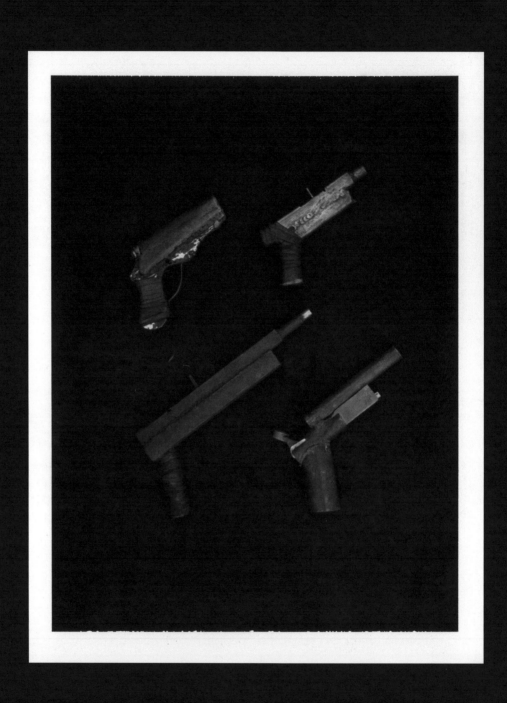

ACKNOWLEDGMENTS

My deepest love, inspiration and gratitude to my daughter Ava and partner Elizabeth.

My thanks to my mother and all the members of my family, the Tadic family, Allan Omara and the Kips Kaboni boys, Ben Bohane, Rocky Roe, Alexandre Spalaikovitch, Ilya Gridneff, Liam and Jemima Fox, Bob Connolly, Stephen Pinson, Marshall Webber, Felice Tebbe, Jacques Menasche, Robert Pledge, Jeffrey Smith, Dominique Deschavanne and the great staff of Contact Press Images, Jack Bell, Andy Bell, Judy Bell, Gail Newton, Manuela Furci, Alasdair Foster, Matthew Carney, Mark Corcoran, Sean Davey, Malum Nalu, Jim Elmslie, Evan Williams, Jack Picone, David Dare Parker, Tim Page, Marianne Harris, Wim Melis, Maria Merino, Brendan Beirne, Lucy Pinter, Jan Welters, Peter Holder, Kevin Cooper, Shayne Peace, Chris Reid, Rocky Roe, Jim Elmslie, David Blackall, Jean-Francois Leroy, Giullaume Jan, Moshe Rozenzveig, David Friend, Anna D'Addario, Warren Macris, and Joy of Giving Something.

Thanks to all the team at powerHouse for their dedication to the project, Alex Martin, Nina Ventura, Will Luckman, and Wes Del Val. Especially thanks to Craig Cohen for your vision and guidance, and for making this book a reality.

Thanks to the support of the Gardner Photography Fellowship at the Peabody Museum of Archaeology and Ethnology at Harvard University.

To Mark Worth for opening the door into the madness and mystery of Papua New Guinea. For your laughter, stories, and friendship. Rest in peace comrade.

Raskols: The Gangs of Papua New Guinea

Photographs © 2012 Stephen Dupont
Introduction © 2012 Ben Bohane

Published in the United States by powerHouse Books,
a division of powerHouse Cultural Entertainment, Inc.
37 Main Street, Brooklyn, NY 11201-1021
telephone 212.604.9074, fax 212.366.5247
e-mail: raskols@powerhousebooks.com
website: www.powerhousebooks.com

First edition, 2012

Library of Congress Control Number: 2012938391

Hardcover ISBN: 978-1-57687-601-5

A complete catalog of powerHouse Books and Limited Editions is
available upon request; please call, write, or visit our website.

10 9 8 7 6 5 4 3 2 1

Printed and bound in China through Asia Pacific Offset